IMAGES
of America

OXFORD CIRCLE
THE JEWISH COMMUNITY OF
NORTHEAST PHILADELPHIA

Other works by Allen Meyers:

The Jewish Community around North Broad Street
The Jewish Community of South Philadelphia
Strawberry Mansion: The Jewish Community of North Philadelphia
The Jewish Community under the Frankford El
The Jewish Community of West Philadelphia

IMAGES
of America

OXFORD CIRCLE
THE JEWISH COMMUNITY OF
NORTHEAST PHILADELPHIA

Allen Meyers

ARCADIA
PUBLISHING

Published by Arcadia Publishing
Charleston SC, Chicago IL, Portsmouth NH, San Francisco CA

Printed in the United States of America

Library of Congress Catalog Card Number: 2004104491

For all general information contact Arcadia Publishing at:
Telephone 843-853-2070
Fax 843-853-0044
E-mail sales@arcadiapublishing.com
For customer service and orders:
Toll-Free 1-888-313-2665

Visit us on the Internet at www.arcadiapublishing.com

On the cover: A parade is led up Bustleton Avenue by Sam Lerner (left) and Ellie Rosenblatt (right) in 1976. (Courtesy of Scott Weiner.)

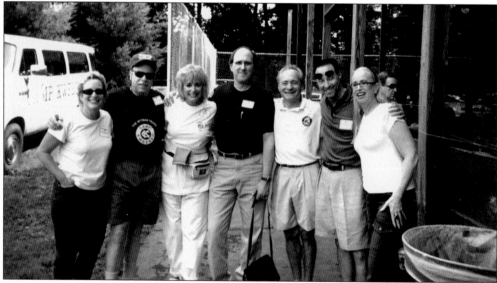

This book is very special for those who grew up in Northeast Philadelphia during the 1940s, 1950s, and 1960s. Some kids, including the "Devereaux Street Indians," have made friendships from their childhood that have lasted a lifetime. That group of friends from the 1400 block of Devereaux Street in the Oxford Circle off Roosevelt Boulevard exemplifies the era in which you could go out your front door and find scores of Jewish children your own age, ready to engage in fun activities. This sense of community is still present today. Shown gathered at Camp Kweebec, in Shenksville, are Lisa Kurland, Neil Weissman, Arlene Shenkman, Neil Levitt, Allan Witman, Gene Shulman, and Judy Kurland. The camp was owned at one time by Herman Witman, father of Allan.

CONTENTS

Acknowledgments 6

Introduction 7

1. Coming to the Northeast 9

2. GI Appreciation 19

3. Family, Friends, and Neighbors 25

4. My Back Driveway 39

5. Riding Public Transportation 45

6. Community Schools 53

7. Favorite Places to Go 65

8. Shopping Districts and Centers 77

9. Neighborhood Synagogues 93

10. Community Affairs 111

11. The End of an Era 123

ACKNOWLEDGMENTS

The opportunity to share with thousands of people the history of the Jewish community of Philadelphia through its various Jewish neighborhoods is a life work in progress, which started 25 years ago after the passing of my maternal grandparents, Rose and Louis Ponnock. This labor of love came about in order to pay tribute to the lifetime achievement of my grandparents and now has extended to include the full community. I want to thank the staff members at Arcadia Publishing for their support and commitment, which has allowed six books on the same Jewish community to come to fruition over the last seven years. My wife, Sandy, is a hero, who kept asking when are you going to finish all this book writing and do some home chores. I am gratefully indebted to her for her support and sacrifice. Last of all, I want to thank my longtime friend and employer, Frank Collison, who has granted me license to complete my life's work while at the King of Prussia McDonald's for the last five years. It has been fun and rewarding to touch so many people's lives, just as my grandparents did. Their tombstone, in fact, reads, "The Deeds One Does Lives After Them."

You can contact Allen Meyers at 11 Ark Court, Sewell, New Jersey, 08080. Telephone: 856-582-0432. Fax: 856-582-7462. E-mail: Meyers.A@Worldnet.ATT.net. Web site: www. JewishPhillyNeighbors.com.

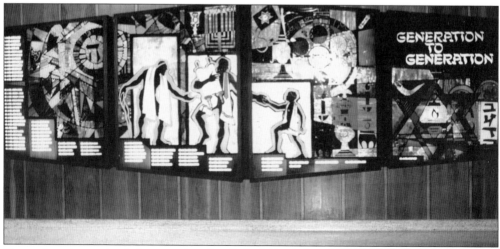

Shown here is a stained-glass mural at the Oxford Circle Jewish Community Centre.

INTRODUCTION

History, culture, and heritage best describe the formation of the Jewish community in Northeast Philadelphia. What developed in the 20th century along the premier thoroughfare known as Roosevelt Boulevard can best be described in its full context as a complete community, full of practical ideas and theories put to the test on a daily basis while ordinary Jews went about the business of raising many families. The richness and diversity in this community derived from this experience is little known in the literature.

A multitude of urban development factors served as the basis for this great community in America, known as Northeast Philadelphia's Jewish community. The design and construction of the modern 12-lane superhighway northeast of Broad Street and the Jewish community of Logan came to fruition in the second decade of the 20th century after a decade of planning. The construction of homes on either side of Roosevelt Boulevard, plus the advent of the transportation system under the leadership of the Philadelphia Rapid Transportation Company with its many trolley car lines, elevated railroad from the downtown area out to the green open pasturelands of the Northeast were accessible by new double-decker buses along the A route.

New housing designs, with homes that had driveways and garages for automobiles in the rear of the properties were then recent designs of the day. Everyday conveniences included the invention of the telephone, inside plumbing with running water, appliances that ran on electricity, and iceboxes, all of which allowed people to live farther from the center of the city, where jobs were plentiful.

New migration patterns from the older, stable Jewish neighborhoods of South, North, and West Philadelphia gave rise to a cultured middle class of many Jewish residences. The urge to better oneself is a trademark of the Jewish people in Philadelphia once- and twice-removed from the ships that brought many eastern European immigrants to the shores of Philadelphia in the late 1890s and early 1900s.

Another little-known fact altered the course of history as far as land available for the eventual expansion and true development of the Oxford Circle Jewish community. With four Jewish cemeteries east of Roosevelt Boulevard near Bridge Street, and the creation of the Montiefore Jewish Cemetery in 1910 in Rockledge, Pennsylvania, 10 miles northwest of this area, along with the Har Nebo Cemetery, founded in 1890 along Oxford Avenue, there were ample graves for a growing Jewish immigrant population. An additional 225 acres were deeded and available to Har Nebo Cemetery in a north-northeast direction but were never used, as the severity of the 1918–1919 flu epidemic came to a halt. The land lay in the hands of farmers, until the need for additional housing developments began after World War II along Summerdale and Algon Avenues, up to Unruh Avenue.

Housing shortages during and after World War II were lessened with the construction of many homes by Jewish builders, including Hyman Korman and A. P. Orleans. Whole families were on the move during the late 1940s, led by children of immigrants. The Colonial-style design of the homes lent itself to the theme of a new era, and whole villages were laid out, complete with schools, libraries, post offices, reliable public transportation, and convenient shopping along main avenues.

Young Jewish families with children came to define the new Jewish neighborhood of the 1950s. Uncles, aunts, grandparents, and siblings all moved near one another for social likeness to the shtetls, or village living, of the last century. Jewish children could have access to the older generation to experience a wealth of real-life lessons. By some standards, it was an old world custom for couples just starting out to live with the wife's parents.

Whole blocks of Jewish residents from South, North, and West Philadelphia reconstituted themselves in the Northeast, as the older settlements gave way to a new generation after World War II. Some Jewish shop owners, like the Skaler kosher meat market, which moved from 40th and Ogden Streets to the 6700 block of Bustleton Avenue in the early 1950s, picked up their roots and transplanted themselves to more fertile business environments. The growth of the Northeast community, along with the development of the Tacony-Mayfair and Feltonville Jewish communities, gave way to the Oxford Circle and Rhawnhurst communities farther up Roosevelt Boulevard and east of Castor Avenue. In all, 10 communities opened up to Jewish residents, and by the early 1960s, they included Fox Chase and Verree Road up to Bustleton Avenue. Welsh Road on the east side of Roosevelt Boulevard near the E. J. Korvettes department store, along with Morrell Park in the far Northeast, gave Jews the opportunity to move a second time within the borders of Northeast Philadelphia in the late 1960s, when new housing attracted many young Jewish families.

In the 1970s, Russian and Israeli Jewish immigrants settled in new housing in the Northeast neighborhoods of Philmont Heights, only blocks away from the prestigious Philmont Country Club, founded by German Jews in the early 1900s, and in Somerton, where the Jewish population exploded to 120,000 during the national bicentennial celebration in 1976.

In the late 1980s, two out of five Jewish people were documented as being on the move throughout the Northeast due to various social factors. The aging process and the start of families by children who grew up in Northeast Philadelphia best explained two such groups. The erection of seven high- and low-rise apartment complexes, known as Federation housing, served a growing aging Jewish population on fixed incomes. Some moved into modern apartment buildings near Welsh Road and Roosevelt Boulevard, while others selected gated apartment and condominium communities along the Delaware River, such as Baker's Bay and Delaire Landing. Still other members of the community migrated to warmer climates, such as Florida or Arizona, and some left the comfort of home for new communities in Lower Bucks County, in Newtown, Yardley, and in Richboro, led by native northeasterner Rabbi Elliot Perlstein at Ohev Sholom. Younger families migrated across the Delaware River to Cherry Hill and Washington Township in South Jersey.

The closing of a neighborhood is difficult to realize in any one generation by the same population. First, one witnessed the closing of stores on Castor Avenue (Rosenberg's Hebrew Books) and Bustleton Avenue (Famous Deli), along with many kosher butcher shops. Next came the closure of the Newman Senior Center and familiar synagogues, along with the senior center in early 2004.

Society as a whole is set to reflect the opportunities in the world according to mostly economic developments. There is a revival happening in the Northeast Jewish community as it prepares to start its third generation. Modern Orthodox Jews have claimed the area in the Rhawnhurst section as their own with the opening the Harry Stern Jewish Hebrew High School in 2004.

One

COMING TO THE NORTHEAST

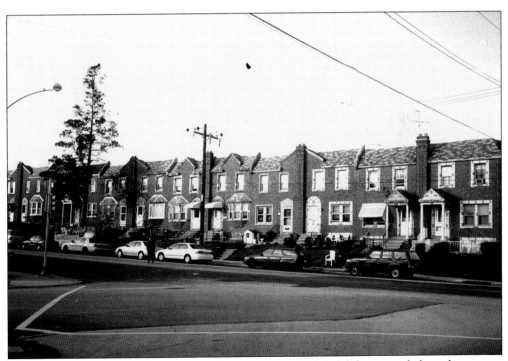

The once pristine farmlands in the northeast section of Philadelphia provided ample room to build new communities after World War II, such as the one shown here at the intersection of Loretta and Magee Avenues in Oxford Circle. This community of row homes with front lawns afforded thousands of Jewish people less cramped living conditions than the more traditionally Jewish neighborhoods of South Philadelphia, West Philadelphia, and Strawberry Mansion.

Settling into a new neighborhood, an adventure all by itself, was often made easier by real estate agencies, such as City Wide Realty Company, founded by Edwin and Belle Adler, who came from 40th Street and Girard Avenue in West Philadelphia. The couple started their business in 1948 in the Frankford section. Realizing the opportunity to be ambassadors to Oxford Circle newcomers, they relocated to Bustleton and Unruh Avenues in 1951 to represent Joseph Cutler, a prominent builder in the area. Edwin Adler passed away in June 2004. (Courtesy of Paul Adler.)

The opening of Oxford Circle as a new community in the 1940s led to the creation of a realty board, directed by the well-known and respected Harry Toben, a native of the Kensington section of Philadelphia. With a charter for the Oxford Circle Realty Board drawn up by Lou Linett, 25 realtors, including Alex Burchuk, Martin Hyman, and Edward Ludwig, banded together to provide a multiple listing service, which helped direct the migration into the northeast part of the city in an orderly manner. (Courtesy of Harry Toben.)

Typical building lots measuring 150 feet deep by 18 feet wide proved to be the most popular models for homes constructed by builders such as Korman, Orleans, Cutler, Simon, Feldscher, and Fisher. The amenities included long lawns, cement patios, front vestibules, powder rooms downstairs, three bedrooms upstairs, a modern kitchen, and a large living and dining room. These houses were perfect for young families and came with an unfinished basement and a garage in the rear.

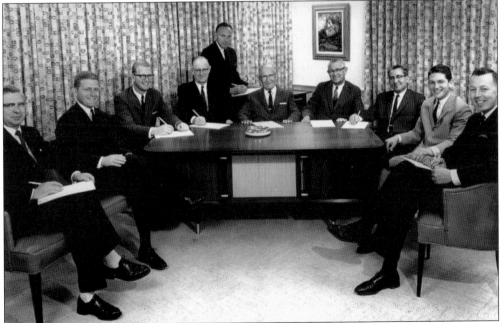

The well-known family of Korman homebuilders originated when Hyman Korman came from Europe in the early 1900s and settled on the former Hamilton Farm at Oxford Avenue and Levick Street. In 1933, Hyman's son Max built a stone house at 1415 Brighton Street. The farms of Northeast Philadelphia were turned into new homes by these men, seen here in 1963. They are, from left to right, Bill Healy; Len, Berton, Max, Hyman, and Sam Korman; Barney Moss; Steven Korman; Frank Elliott; and Murray Isard. (Courtesy of Len Korman.)

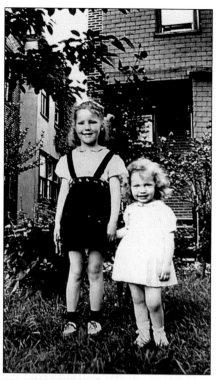

Access to Northeast Philadelphia started in the early 1920s, when Jewish people migrated from South Philadelphia on the Route No. 50 trolley car line some 15 miles away to the treelined streets of Feltonville, near Roosevelt Boulevard and Rising Avenue. In this photograph, Doree and Mimi enjoy a summer day in their backyard. (Courtesy of Lillian Rosner.)

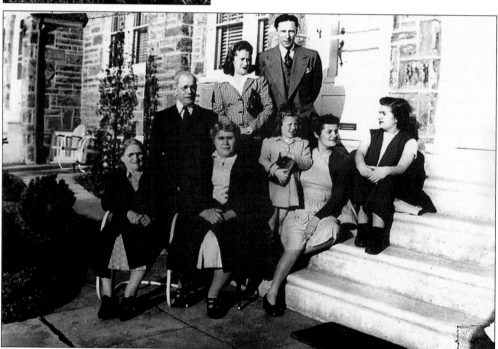

Jewish geography is more than sharing the same neighborhood with other people of your same background. Family life is the key to successful transplantation from one area to another, as represented by these residents on Castor Avenue, congregated on the steps for a family snapshot in the spring of 1942. (Courtesy of Linda Waxman.)

Morton Krase, a resident of the older neighborhood of Logan, poses here with his mother in front of their newspaper, tobacco, and variety store at Levick Street and Rising Sun Avenue, a busy intersection for commerce along the trolley Route No. 50, adjacent to the large tract of land known as Fischer Farms. (Courtesy of Judge Morton Krase.)

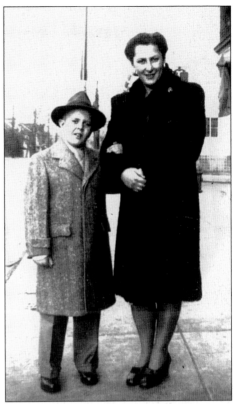

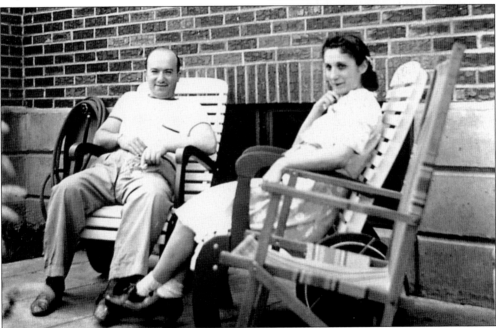

Mollye and Rudolph Jasenof enjoy a moment of relaxation on their patio at 1418 Benner Street in Oxford Circle in the summer of 1944. The couple raised their son Ken in this row house. (Courtesy of Ken Jasenof.)

Oxford Circle matrimony is reminiscent of shtetl life in Russia, where boy meets girl in the same community and they live happily ever after. Jack Kapenstein and his wife, Bonnie Bluestein, both from Oxford Circle, were married in the late 1970s. The couple now resides near the Solly Avenue Playground in the Rhawnhurst section of Northeast Philadelphia. (Courtesy of Jack Kapenstein.)

What a couple Ida and Leonard Block have made for the past 50 years! The dream of growing and maintaining a victory garden attracted the pair, who visited family on Greeby Street in Oxford Circle during the 1940s. Little did they know that the same piece of ground they tended (1041 Levick Street) would one day provide a house to shelter their future dreams. (Courtesy of Len Block.)

Here we see Albert and Shirley Rednor, who have been together for 45 years, after the founding of the Mr. and Mrs. Club at Temple Menorah. The couple operated a dentist's office on Frankford Avenue and have lived in one house, within walking distance, since that time. (Courtesy of Albert Rednor.)

Shown are Elayne and Irv Smiler 40 years after the founding of the "seniors' club," a group of young people in their 20s who met socially at Temple Menorah on Tyson Avenue in the Mayfair section. Irv, a longtime foot doctor, shared his life with the community at large every single day. He led the Bridge-Pratt Street Business and Professional Association for many years until his death in 2003. (Courtesy of Elayne Smiler.)

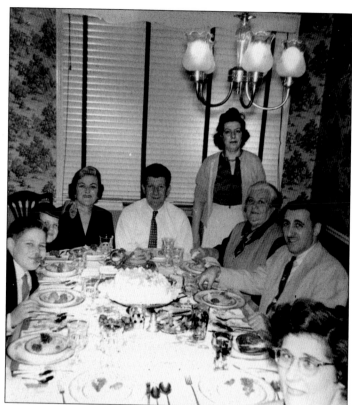

Family dinners became the welcome mat for introducing relatives to Oxford Circle. The Waxman family invited everyone to their home on Disston Street on Friday nights for some good, home-cooked Jewish foods, as seen here in 1958. (Courtesy of Linda Waxman.)

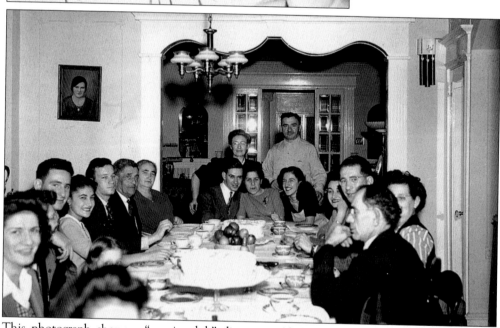

This photograph shows a "cousin club" dinner in 1942 at 242 Roosevelt Boulevard. The Lamperts, Rothsteins, and others gathered on a regular basis to share each others' company during an uncertain time in our country's history. The dinners continued after World War II. (Courtesy of Lillian Rosner.)

In the summer of 1954, Toby Shaffner Shigel schlepped with her parents from 5737 Addison Street in West Philadelphia to visit her *bubbe*, Sarah Schecter, at 1000 St. Vincent Street in the Castor Garden section of the Northeast. (Courtesy of Joel Shpigel.)

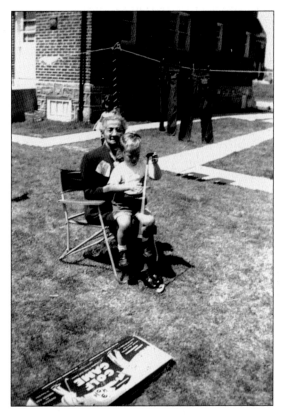

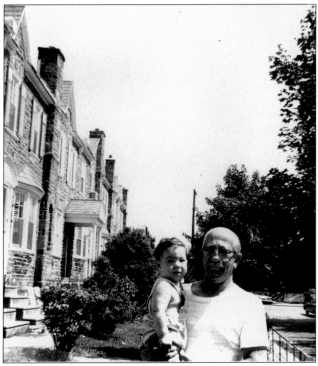

For Steve Feldman, going from Napa Street in Strawberry Mansion to the 7000 block of Kindred Street to see his grandparents was a Sunday ritual in the summer of 1956. (Courtesy of Steve Feldman.)

17

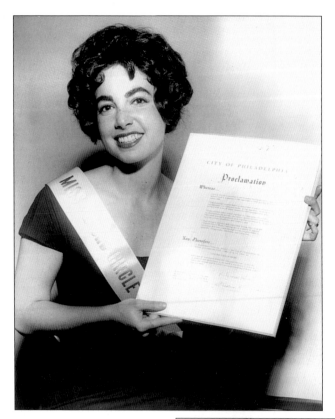

Miss Oxford Circle for 1955 was the lovely Fleurette Gilman, age 19, from 6276 Kindred Street. She was crowned by Herman Cohen at the Max Myers Playground to help inauragate Northeast Week, which promoted goodwill throughout the city's various neighborhoods and among various religious faiths. The next step entailed a tryout for Miss Greater Philadelphia. She was spotted by her future manager, Joel Wattenmaker, and a business relationship turned into a romantic one. The couple married in the early 1960s. (Courtesy of Fleurette Gilman Wattenmaker.)

The family that got together for regular Friday night dinners stayed together, as all the siblings moved within walking distance of each other near Glenview Street and Bustleton Avenue in the early 1950s. (Courtesy of Tracy Kauffman.)

Two

GI APPRECIATION

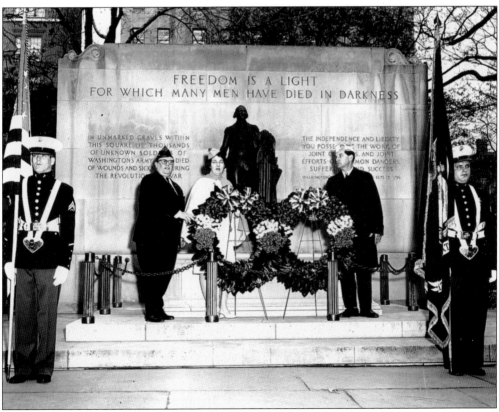

The Jewish service veterans of World War II commemorate their contributions to the United States of America annually, with a memorial service at this monument in Rittenhouse Park. (Courtesy of the *Jewish Exponent*.)

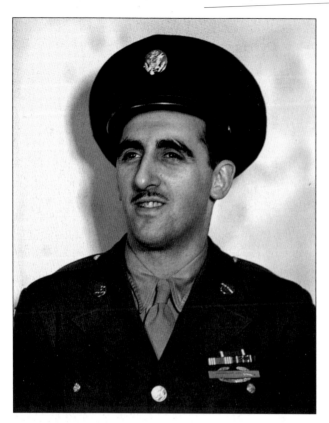

David Korsun takes time out in the spring of 1945 to pose for a photograph in his service uniform after he received wounds in combat. (Courtesy of Linda Waxman.)

A long way from home while being trained for combat at Camp Van Dorn in Mississippi, men found themselves looking forward everyday to mail call. Their connection to a home base did not lessen the loneliness of the mission of these men, who were hundreds of miles from family and friends. (Courtesy of Linda Waxman.)

What a bunch of proud sailors and officers are seen here aboard the USS *Douglas* on June 6, 1945. The men were in port at San Pedro, California, waiting for discharge from the service after arriving home from the Pacific theater of operation. (Courtesy of Len Block.)

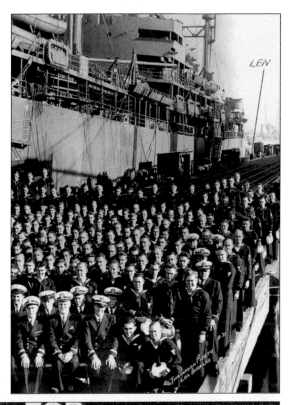

FOR
"GALLANTRY AND HEROISM"
TO
SEYMOUR GRAY
E.T.O. 1942 - 1945
ARMY OF THE UNITED STATES
THE SILVER STAR

Seymour Gray, a native of the Strawberry Mansion section of North Philadelphia, and later of Northeast Philadelphia, measured up to his duty and did a heroic job while in Nazi Germany during World War II. Seymour made a valiant effort when his commanding officers were all killed in battle, covering his fallen buddies' bodies with his own, then rallying the troops to capture a small town. Seymour was recognized for his quick thinking actions with a Silver Star from the U.S. Army. (Courtesy of Seymour Gray.)

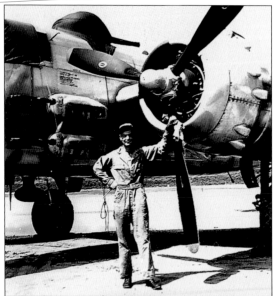

Harry Toben, a native of the Kensington section of Philadelphia, joined in the World War II effort by enlisting in the air force. Toben flew B-29s and had the opportunity to tour the world. Here, we see him posed with his aircraft in Natal, Brazil, in July 1944. (Courtesy of Harry Toben.)

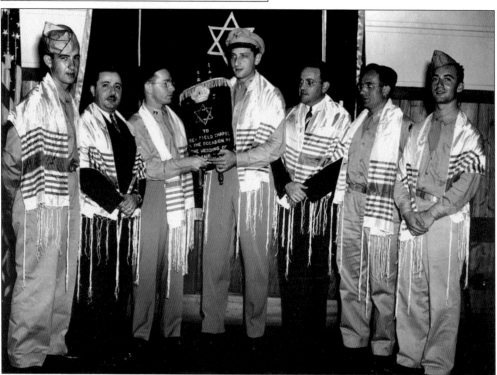

The Jewish chaplains of World War II engaged in religious observance while serving their country. The men wore their informs and were free to practice their religion on a timely basis, as well as celebrate their heritage and culture, even while away from home on military duty. Rabbi Pinchos Chazin, second from the left, came to military service from Beth Judah in West Philadelphia. After the war, Rabbi Chazin assumed the pulpit of Temple Sholom on Roosevelt Boulevard in Oxford Circle, a position he held for the next 50 years. (Courtesy of Rabbi Pinchos Chazin.)

The Block family, on a tour of leave, have some fun at the end of World War II in this staged photograph taken in the U.S. Navy's Long Beach, California, brig. Sylvia Block and her son, Harry, traveled to the West Coast to welcome their loved one home after his service in the Pacific theater of operation in 1946. (Courtesy of Len Block.)

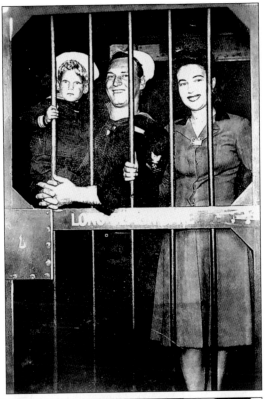

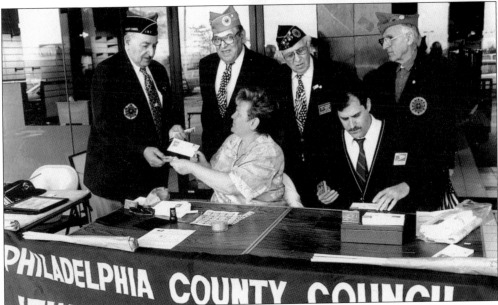

A special postage cancellation in 1996 at the Roosevelt Mall marked the 100th anniversary of the Jewish War Veterans in America. Those honoring this special milestone in Jewish life included Catherine Pembroke (seated), who handed the canceled cachet to Albert Yavit, commander of the Philadelphia County Jewish War Veterans. Leon Richman, Bernard Elkin, Joseph Donsky, and Willy Herbst were also in attendance. (Courtesy of the *Jewish Exponent.*)

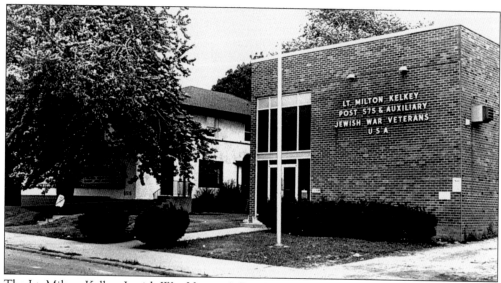

The Lt. Milton Kelkey Jewish War Veteran's Post No. 575 dates back to 1946, when several air raid wardens in the Strawberry Mansion section of North Philadelphia decided to honor the passing of this well-known individual, who died in combat in 1942. The post decided to migrate in 1954, with its members, to the Oxford Circle section of Northeast Philadelphia. The post built its social hall, which accommodated more than 500 members, at 6513 Bustleton Avenue. (Courtesy of Allen Meyers collection.)

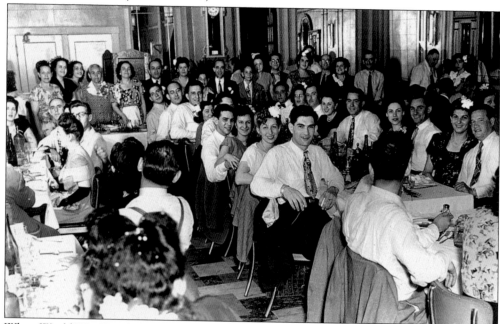

When World War II ended, life for many Philadelphia Jews started over again. The reunification of the family took on a whole new meaning and cousin clubs proliferated throughout the city. The return to one's roots took place for the family of Bertha Roth on May 25, 1946, at the Colonial restaurant, a favorite venue in South Philadelphia at Fifth and South Streets. The Freedmans, Dannys, Sellers, Chirlins, Levins, and Misloffs came together to fortify each other and return to normal life. (Courtesy of Bertha Roth.)

Three

FAMILY, FRIENDS, AND NEIGHBORS

The summertime brought friends and neighbors together in all the neighborhoods around Philadelphia. Great conversation could be enjoyed for hours on end in front of one's own home on concrete patios, built with pride by the Korman family of builders throughout Oxford Circle. This great gathering place added the sense of community expressed in other sections of the city by sitting on the stoops or on beach chairs placed on the sidewalks of many homes. The talk of world events was spiced up with plans for future life-cycle events, and carried on until the Jack Parr television program began around 11:00 p.m. (Courtesy of Marsha Berman.)

The front steps of many homes became a favorite place to snap photographs of the children. The home of Lillian Rosner, at 242 East Roosevelt Boulevard, was no exception, as we see in this June 1943 photograph. The welcome mat of many homes in many Philadelphia neighborhoods included a wooden bench outside. The children were usually asked to make faces for the "birdie in the camera." (Courtesy of Lillian Rosner.)

Pride is the main ingredient in all of these family photographs. Bertha Roth is clearly very fond of her daughter and their home in this photograph taken in the early 1950s. (Courtesy of Bertha Roth.)

26

Sylvia and Len Block spared no expense in the 1950s to capture the youth of their children, especially when there was a professional photographer and close relative (Carl Sokoloff) in the house. (Courtesy of Sylvia Block.)

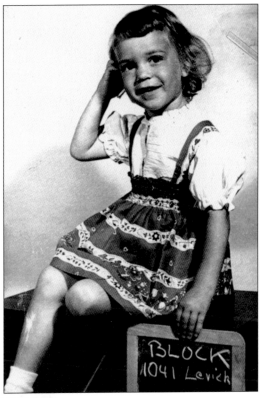

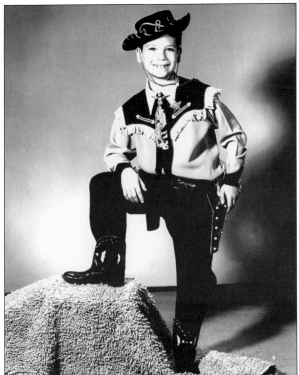

Dressing up to play cowboys and Indians captured the momentum of the era in which Jewish children such as Harry Block took exceptionally well to posing. The scenery shot for boys with toy guns provided the only way to portray a staged pose, since many Jewish parents did not permit guns in their homes, and the children were discouraged from playing with toy guns. (Courtesy of Len Block.)

27

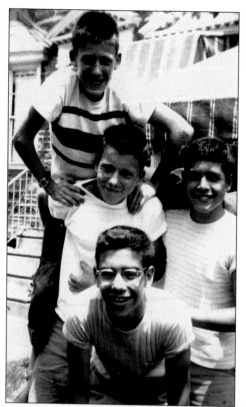

The Devereaux Street Indians consisted of scores of children in the same age bracket who lived near Devereaux Street and Roosevelt Boulevard in the 1950s. The children went first to the Carrnell public school and then later, due to overcrowding, to a new school, Spruance, only a few blocks away. During the summertime, David Sasskind, Billy McGarvey, George Meir, and Murray Sussman played many street games familiar to Philadelphians, such as box ball, half ball, wire ball, and step ball. (Courtesy of Allan Witman.)

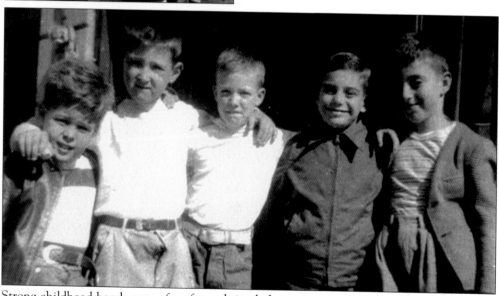

Strong childhood bonds were often formed simply by coming out your front door and playing with other children your own age. Murray Rubin, Neil Levit, David Birnbaum, Allan Witman, and Murray Sussman had this great and wonderful experience and remained friends for life. The children varied their activities in their neighborhood and traveled to different playgrounds such as Max Myers and Tarken, yet they always returned home to their back driveway to pal around. (Courtesy of Allan Witman.)

Groups were in, and these typical Oxford Circle girls—Sandy Timerman, Reenie Flaxman, Sandy Freedman, Shelly Lazar, and Sharon Brown—kick up their heels in unison on one of the girls' front lawns. The girls formed an integral arm of the club known as the "Devereaux Street Kids," whose members mingled in school and in Hebrew school at nearby Temple Sholom synagogue. (Courtesy of Allan Witman.)

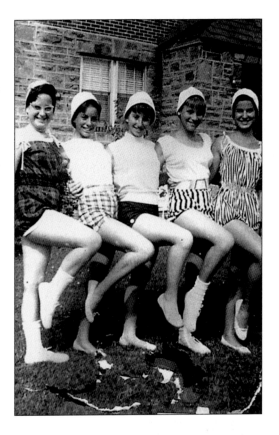

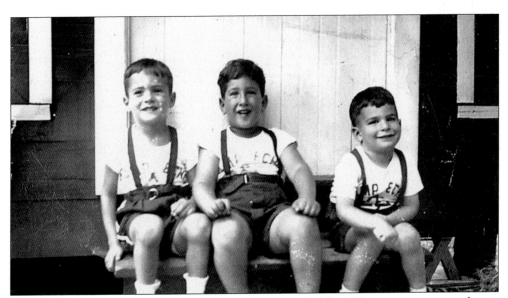

Here we see three little boys—Joe Fisher, Art Lerner, and Allan Witman—sitting together in the same fashionable clothes of the day as they enjoy going off to a day camp. The socialization of boarding a school bus every morning in the summertime allowed neighborhood boys to think of each other as family. (Courtesy of Allan Witman.)

Teenage friends from Oxford Circle hang out together here in full view of their parents, without a thought of mischief. Jackie Pienne, Barbara Axler, Myra Katz, and Ronnie Weller enjoyed each others' company on the 2100 block of Magee Avenue before leaving for a malted shake at the Tyson Grille on Bustleton Avenue. After that, they usually went over to Linton's restaurant on Castor Avenue to visit with other friends from Fels Junior High School. (Courtesy of Ken Jasenof.)

Friendly gatherings moved from the parlors in traditional Jewish neighborhoods to the finished recreation rooms in Oxford Circle homes. Young adults could meet there for coed parties, still under the same roof as their parents, but with some privacy. Parents' trust of their children ensured that a good party on Halloween included punch, party favors, and lots of rock-and-roll tunes played on the new stereograph record players. (Courtesy of A. Sorens.)

30

Ileane Druker came from Strawberry Mansion to visit with her grandparents and to soak up the sun in the 6600 block of Kindred Street. This late-1950s snapshot featured the then new, full-length aluminum web lounge chair, which could be schlepped to the beach if needed. (Courtesy of Steve Feldman.)

Big grassy lawns attracted many former West Philadelphia residents to Northeast Philadelphia. Proud grandfather Alexander Meyerowitz shares a moment here with his grandson, Jay Pollack, at 693 Mayfair Street in 1952. Alexander and his wife, Elsie, of 765 Garland Street, were the grandparents of the author, Allen, and of the author's brother Mitchell and cousins Amy, Clifford, Steven, Diane, Pam, and Sandy. Alexander lived to see only one grandchild before his death in 1953. (Courtesy of Allen Meyers collection.)

The urge to do something positive for your country came from President Roosevelt during World War II, when he urged every American to plant a victory vegetable garden whereever they could find ground. Martin and Beatrice Block migrated to 1314 Greeby Street in Oxford Circle from Strawberry Mansion and planted their garden where new houses would rise up the very next year. (Courtesy of Len Block.)

One could see around corners in this part of Oxford Circle, especially if you lived at 7115 Horrocks Street off Bustleton Avenue. Ray Berman and his wife, Marsha, decided to stay in the Northeast after they married in 1967. The rewards were many when it came time to photograph the family. (Courtesy of Ray and Marsha Berman.)

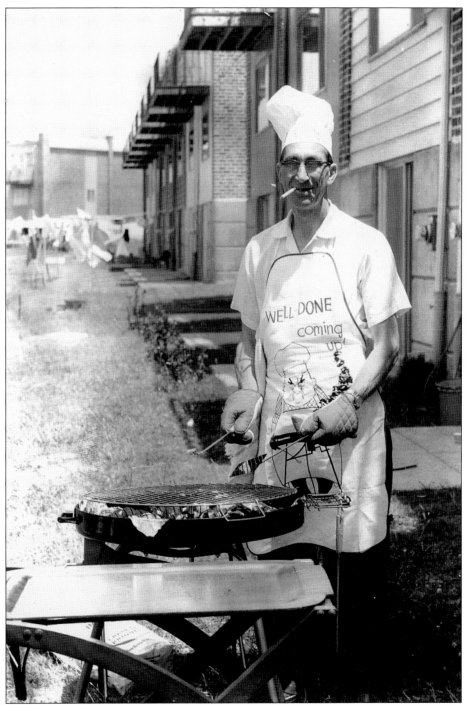

The Bermans prided themselves on the ease with which they relocated around Northeast Philadelphia. Ray lived in apartments before finding his true home in the Academy Road section in the 1960s. Privacy fences did not exist on the 3600 block of East Crown Street when Ray treated his friends to an old-fashioned barbeque out back, complete with a chef's hat. (Courtesy of Ray Berman.)

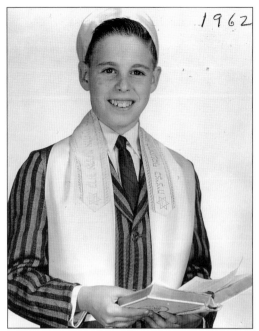

1962

The famous bar mitzvah portrait had to be taken with great care, since it would hang in the living room of one's home for all family, friends, and neighbors to admire when they came to visit. Murray Lee Roth enjoyed his 1962 portrait when his friends, Bernie Rubin, Alan Cherry, and Steven and Bruce Brown came over after school. The feeling was mutual, since his friends had the same portrait in their homes. (Courtesy of Bertha Roth.)

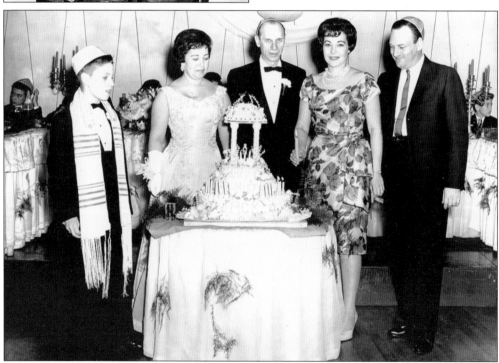

The American Jewish experience peaked with the birth of many children in the post–World War II era. Jewish parents who had worked long and hard to attain great financial security celebrated with their children in lavish affairs to mark the occasion of a bar mitzvah in the early 1960s. This celebration for the bar mitzvah of Jack Rosenbaum in October 1962, attended by Jackie, Bella, and Manny, focuses on a candle-lighting ceremony at the Shelron ballroom at the top of North Broad Street. (Courtesy of Len Block.)

Great joy and pride in neighborhood inclusiveness meant the sharing of the *simcha* with immediate neighbors. Usually the well-wishers stood on the lawns and witnessed the photographs of the event with much glee and thankfulness that it was finally over. Rhoda Roth, the daughter of Lou and Sue, poses here in June 1957 for her confirmation photograph before arriving at the Oxford Circle Jewish Community Centre on Algon Avenue, in the Castor Gardens section of Oxford Circle. (Courtesy of Bertha Roth.)

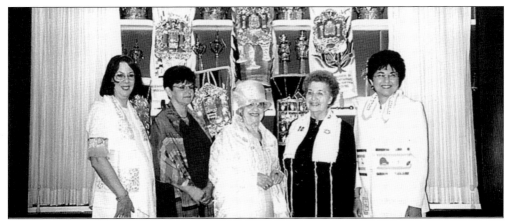

Complete strangers who became neighbors and friends in a new neighborhood shared in the popular ceremony of b'nai mitzvah (in which adult women study the Torah) at the Oxford Circle Jewish Community Centre. Rhea Applebaum is joined by friends on the bema for this very special and joyous occasion.

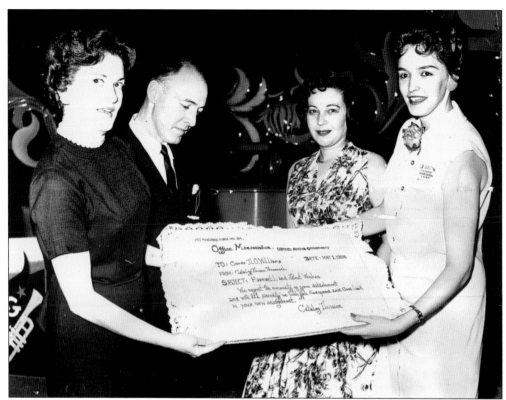

Celebrations took place throughout Northeast Philadelphia, including at the work place. Sylvia Block went to work for the U.S. Naval Supply Depot in the 1950s as a cataloger. The depot was a huge installation on the old Fischer Farm land off Oxford Avenue and Robbins Street. Here, Sylvia Block's co-workers bid their boss good wishes at a going away party in May 1958. (Courtesy of Sylvia Block.)

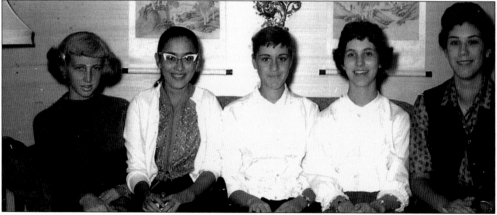

The parlor meetings of the past continued in Oxford Circle as a way to maintain friendship circles. The custom of gathering in the living rooms of mutual friends dates back to the early 1920s in the more traditional Jewish neighborhoods of West and South Philadelphia, as well as in Strawberry Mansion. Faith Gould, Sheila Merzen, Shelley Gould, Linda Kaiser, and Susan Halpern take a moment to relax in this early-1960s photograph. Note the stylish eyeglasses of the era. (Courtesy of Faith Richman.)

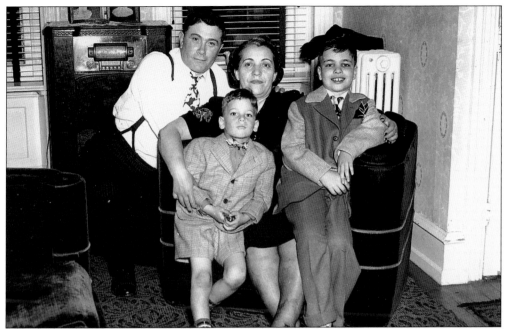

It is easy to determine that this photograph was taken in the 1950s, based on the phonograph-radio console and the mohair furniture on which these folks are sitting. They are Hyman and Rose Fishman, sitting here in front of the old-fashioned radiator during Passover in 1951, along with their grandchildren, Harry and Paul. (Courtesy of Sylvia Block.)

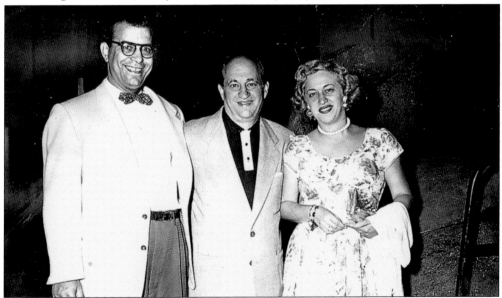

When family comes calling to the new neighborhood, the police sometimes have to be invited to keep the peace, especially if your relative is the one and only Larry Fine of Three Stooges fame. Lyla Budnick (right), the younger sister of Larry Fine, and her husband, Nate (left), share a quiet moment here at their home at 5226 D Street and Roosevelt Boulevard. The police in the 2nd District had to rope off the back driveway and large street to ensure public safety on Sundays in 1954. (Courtesy of Phyllis Budnick Goldblum.)

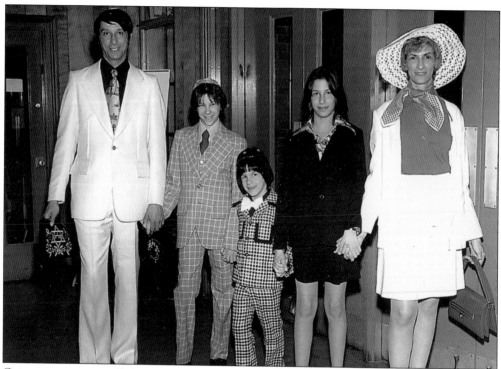

Going to synagogue all dressed up took on a special meaning for the Saltzman family. Arthur and Barbara Feinberg, formerly of Logan, migrated to the Parkwood section of the far Northeast and started out in a brand-new home. In order to be close to *mispocha*, the Saltzmans moved to another new home at 8524 Augusta Street in 1964 and raised their three children, Steve, Richard, and Randi, in Rhawnhurst. Sadly, Barbara passed away in June 2004. (Courtesy of Steve Saltzman.)

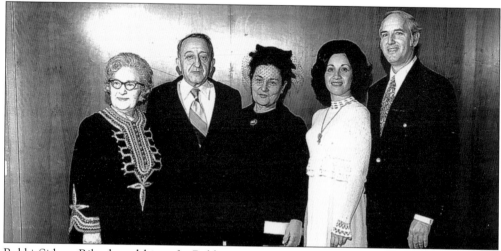

Rabbi Sidney Riback and his wife, Rebbitizen Hilda, counted Miriam Frank and Betty Ann and Donald Gray as good neighbors in the Rhawnhurst section of Northeast Philadelphia. Rabbinical leaders and congregants enjoyed being close to each other as they lived within walking distance of the Adath Tikvah-Moses Montiefore synagogue at Summerdale Avenue and Hoffnagle Street. (Courtesy of Donald Gray.)

Four

MY BACK DRIVEWAY

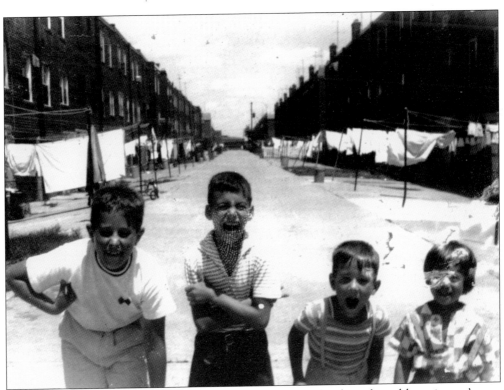

What a way to grow up—safely under the watchful eye of family and neighbors, in one's own back driveway. The Jewish little rascals played with their friends for hours, from morning until dusk, especially in the summertime. The boys went to one section of the driveway, with its smooth concrete surface, to play box ball and bottle tops, with a huge "dead man's box" etched on the ground with chalk. Meanwhile, the girls played hopscotch, baby in the air, and Chinese jumping rope. By late afternoon, all of Tracy Kauffman's friends met to play buck buck, hide-and-seek, and driveway tag. (Courtesy of Tracy Kauffman.)

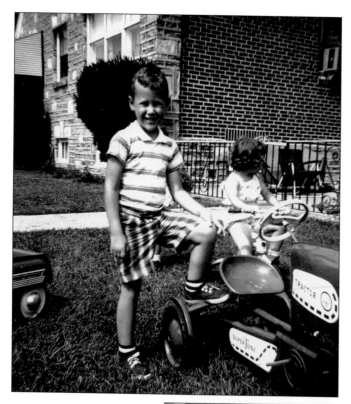

Driveway memories included taking turns riding the brightly colored, pedal-operated tractors and bright red wagons. During the 1960s, Mark Manusov and his twin sisters lived in the 2800 block of Solly Avenue, east of Pennypack Circle, along Roosevelt Boulevard. The children enjoyed their own parklike setting right in their back driveway during the summer, with plenty of room to play on the grass between the twin ranch homes. (Courtesy of Mark Manusov.)

Every boy recalls his first tricycle with training wheels, and the helpful steadying of the bike by both parents, one on each side. Then, in August 1954, came the day Murray Roth of 2021 Glenview Street only dreamed about. At last, he had his own two-wheel bike, complete with front fenders, a horn, and clothes pins holding baseball cards to the spokes to make a loud vroom sound. (Courtesy of Murray Roth.)

Here, Sue Roth, from 2100 Glenview Street, rides tall in the seat of her brand-new walker and rider toy in the back driveway of her house. This was a common sort of sight and often included proud parents beaming as their children enjoyed the fresh air. Most Jewish mothers were homemakers during the 1950s, and they watched their children grow up as they hung clothes out to dry daily on several rope clotheslines. (Courtesy of Bertha Roth.)

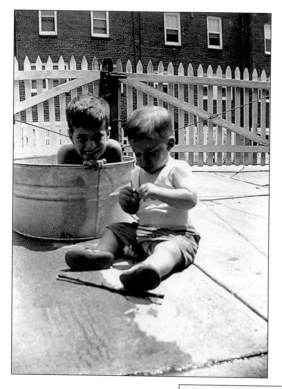

Many parents wanted to share the values of making do with what you have and the simple pleasures they once enjoyed growing up during the Depression years of the 1930s. For many Jewish families in the old neighborhoods in Philadelphia, the backyard only had room for a sitting pool made from a converted wash tub. This arrangement cooled many children in the heat of the summer, as it did Bruce and Marvin Waxman, seen here in 1958 behind their house at 6709 Castor Avenue. (Courtesy of Linda Waxman.)

The advancement of the plastics industry in the 1950s allowed new uses for this pliable material, such as swimming pools. Bob and Gloria Manusov purchased this fantastic home pool for their children, Mark, Sandy, and Linda, to splash in all summer long in 1967. The children's grandparents, Sam and Anna Gendelman, joined in the fun, too. (Courtesy of Sandy and Linda Manusov.)

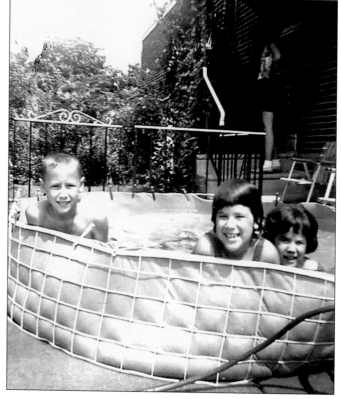

The back driveways of many Northeast Philadelphia neighborhoods provided an outdoor arena for all generations to enjoy. Jewish grandchildren knew their grandparents only as *bubbe* (grandmother) and *zayde* (grandfather). When *Bubbe* Waxman came over, Marvin and his cousin, Rhoda Sirkin, always took a brisk walk in the back driveway for fresh air. (Courtesy of Linda Waxman.)

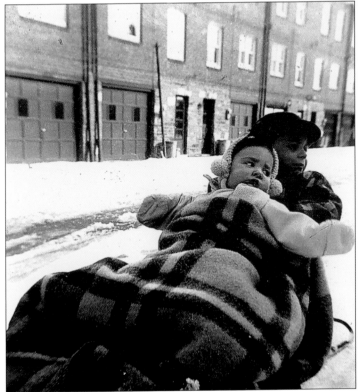

Many an activity took place in the Oxford Circle community playgrounds, but in the wintertime they were chained closed. It seemed that in the late 1950s, Philadelphia received an extra helping of snow from mother nature. Leslie and Murray Roth were bundled in snowsuits bought on Castor Avenue for the occasion of a sled ride, schlepped by their mother in the driveway. (Courtesy of Bertha Roth.)

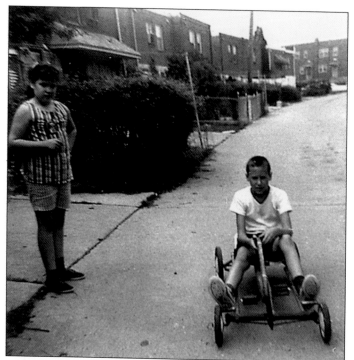

Oh, the multipurpose back driveway we used as children! The terrain in each driveway seemed the same, a flat concrete surface to play on. Some driveways, however, were pitched at just enough of an incline to provide an ideal setting to test out a home made go-cart made of scrap wood. Mark Manusov even added a steering wheel. (Courtesy of Bob Manusov.)

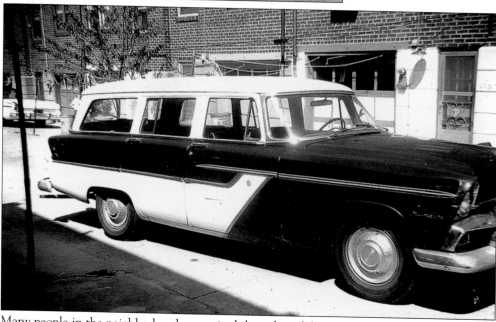

Many people in the neighborhood recognized the value of the common back driveway as more than just a place to park the family car. In order for the children to have more room to play, families occasionally parked the car behind the house, or even out behind the garage. For Bob Krantweiss, reaching age 17 meant being granted permission to borrow his dad's late-model Plymouth station wagon in order to impress his future wife, Susan. Here we see the car in 1966, parked in the back driveway at 1235 Elbridge Street on the occasion of Bob and Susan's second date. (Courtesy of Bob Krantweiss.)

Five

RIDING PUBLIC TRANSPORTATION

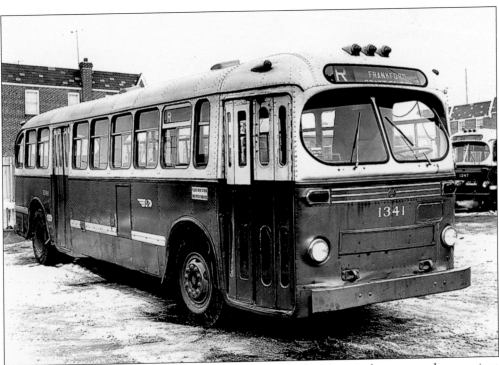

Public transportation connected many a Jewish neighborhood via its low-cost and convenient routes throughout Philadelphia. As Jewish extended families migrated out of the traditional old Jewish neighborhoods, this mode of getting around became the key to visiting friends and family, taking shopping trips, and making the journey to school. The easy access to public transportation with a token (or two for 15¢) sure beat walking to that specific destination. The R bus route replaced the A bus route after World War II, and it traveled from the Strawberry Mansion section of North Philadelphia along Roosevelt Boulevard to the Frankford El terminal for easy connections to 10 different bus lines serving Northeast Philadelphia. The R naturally stood for Roosevelt (Boulevard). (Courtesy of Jeffrey Marinoff.)

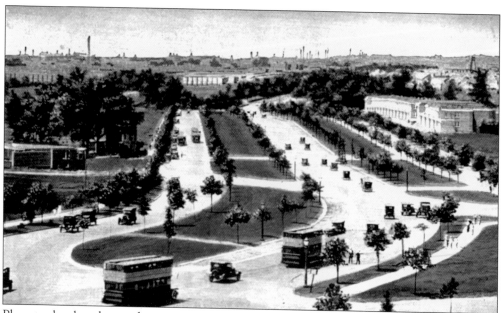

Plans to develop the northeast section of Philadelphia took shape in early 1903. Streets that had been laid out on huge city fire maps were dirt roads initially. Life changed in Philadelphia forever with the initiation of the Torresdale Boulevard, as it was known, which stretched from the end of North Philadelphia at Broad and Hunting Park Avenues along a zigzag course to Route 13 along Frankford Avenue. In 1914, the boulevard went only some 10 miles northeast of its origin, as far the Pennypack Circle. After World War I, in 1922, Northeast Boulevard became Roosevelt Boulevard. (Courtesy of the postcard collection of Gus Spector.)

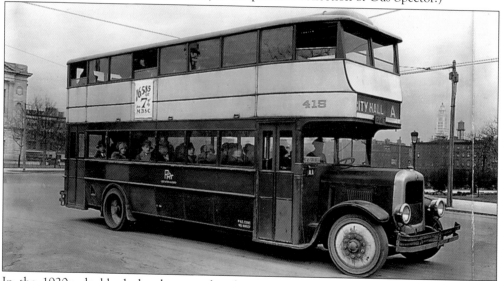

In the 1920s, double-decker buses replaced overcrowded trolley cars as an experiment on the streets of Philadelphia's main thoroughfares. The Route A bus connected city hall with Strawberry Mansion and the new Northeast along Roosevelt Boulevard and to the newly opened Market-Frankford Elevated terminal in the Frankford section. During World War II, the double-decker buses ferried thousands of Northeast Philadelphia residents to the naval shipyard. (Courtesy of Tony Sassa.)

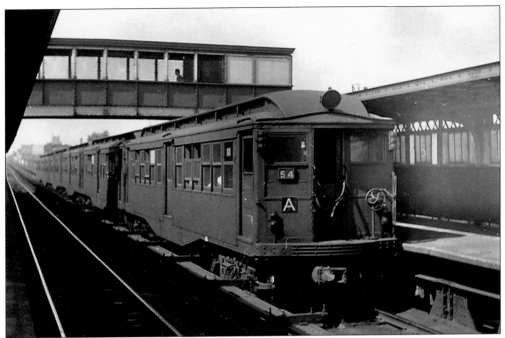

The expansion of the city's population—from both natural effects and eastern European immigration in the early 1900s—led city planners to come up with ideas for enticing the general population farther away from the city's congested core. Plans for the Market-Frankford Elevated were on the books for decades but were put on hold until the 1920s, after World War I. Once the elevated line was built, Northeast residents fell in love with the idea of traveling into town within 20 minutes for shopping and work opportunities. (Courtesy of Dick Short.)

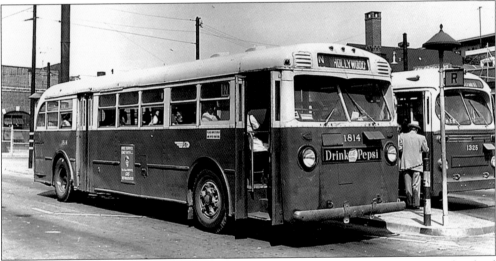

Commuter bus lines fed directly into the Frankford El terminal from the once pristine farmland of Northeast Philadelphia during the 1940s. The new bus lines, which were dedicated with letters, included the Route N, which ran a short distance past the Moses Montiefore Jewish Cemetery in Rockledge. The Route W bus served the area along Verree Road on the far northwest border of the community. Riders were warned to pay attention so they could be sure to board the right bus. (Courtesy of Jeff Marinoff.)

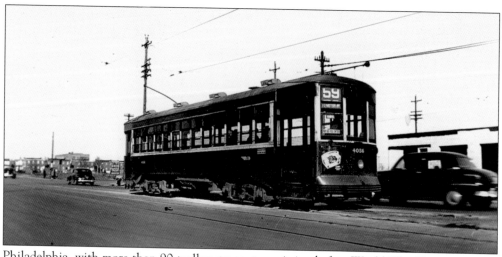

Philadelphia, with more than 90 trolley car routes existing before World War II, captured the title of trolley capital of the world. Jewish communities in Philadelphia existed in large part at the end of the trolley car lines. Builder Hyman Korman, a transplant from Russia to Northeast Philadelphia, had the foresight to begin building new homes on either side of the Route No. 59 trolley car line on Castor Avenue. The line attracted Jewish people to the area, which had been open prarie and farmland. (Courtesy of Dick Short.)

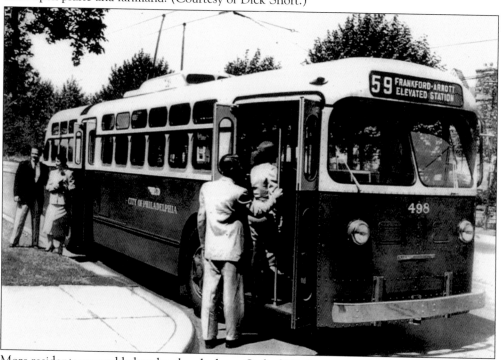

More residents were added to the already dense Oxford Circle section of Northeast Philadelphia after World War II. To meet the demand for more people coming and going downtown via the Frankford El during peak hours, the Philadelphia Transportation Company upgraded its Route No. 59 line to a trackless trolley in 1948. Express service from different corners above the boulevard, and easy access around double-parked vehicles on Castor Avenue made this possible. (Courtesy of Jeff Marinoff.)

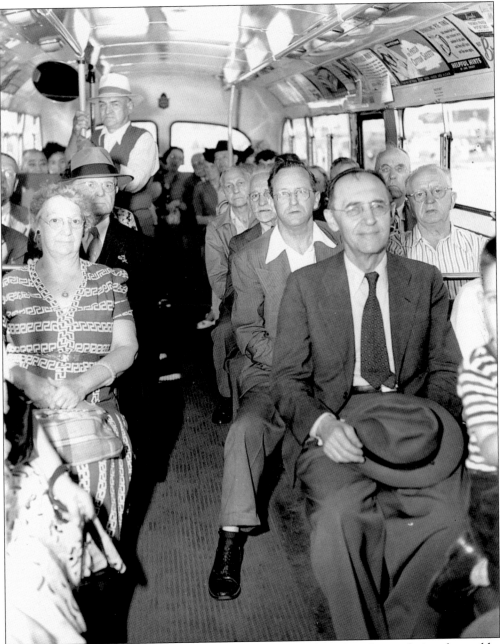

The 1950s ushered in a citywide migration of Philadelphia's Jewish population from older communities to newer ones. South Philadelphians, Strawberry Mansionites, and West Philadelphians migrated to Oxford Circle and the greater Northeast via the city's wide-reaching transportation system. The trackless trolley (electric bus) on Castor Avenue could reach speeds of 40 miles per hour and provided a breeze inside the bus for standing patrons, too. (Courtesy of Jeff Marinoff.)

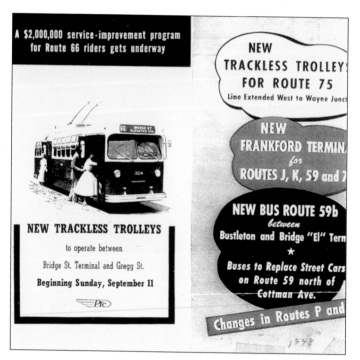

The Philadelphia Transportation Company printed handouts for riders to inform them of upcoming events and changes. In 1949, the company began advertising a $2 million service improvement project, which would upgrade the Route No. 66 trolley car to a trackless trolley from the terminus of the Frankford El to points above this transportation center to the city limits. (Courtesy of Jeff Marinoff.)

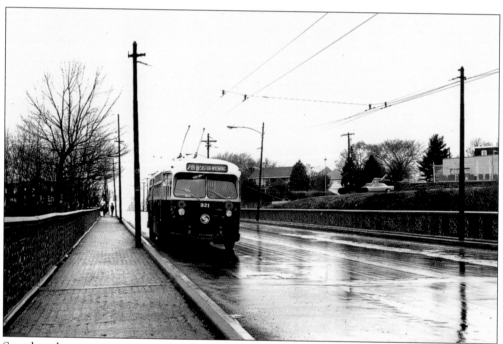

Speed and convenience went hand in hand with the upgrade of three former trolley car lines—Nos. 59, 66, and 75—serving the greater Northeast in the post–World War II era. The conversion of Route No. 75 to a trackless trolley allowed for faster travel between the large Jewish communities of Logan and Feltonville. (Courtesy of Jeff Marinoff.)

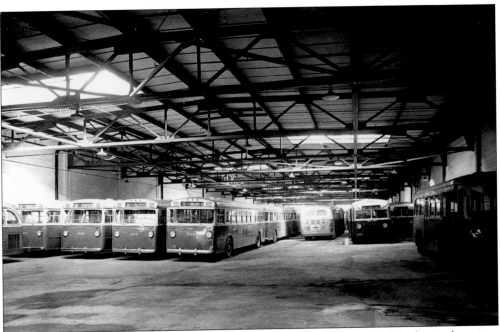

After a full day of service, buses that served the Northeast were "motored" by bus jockeys into their sleeping quarters at the modern bus garage off Bustleton Avenue and Comly Street, only a few blocks north of the Frankford El train yard. This new transportation facility, nestled in a community of row homes, served curious cats seeking shade from the summer sun, and children looking for expired transfer tickets to play "bus monopoly" with. (Courtesy of Jeff Marinoff.)

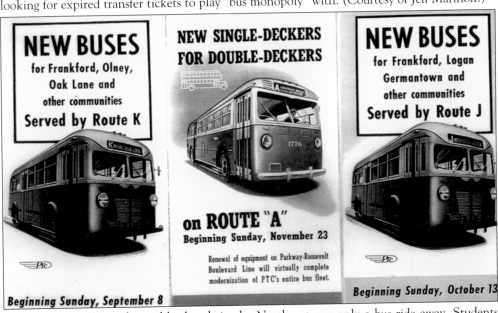

Easy access to all Jewish neighborhoods in the Northeast was only a bus ride away. Students could travel between Logan and Sears on the Boulevard via the J bus on their way to school. Family members visited each other from Oxford Circle to Oaklane, north of the Broad Street subway via the 59 trolley and connections to the K bus with stops along Adams and 66th Avenues. (Courtesy of Jeff Marinoff.)

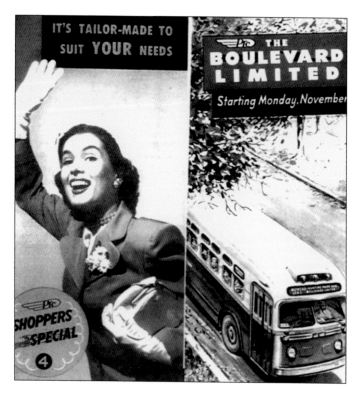

It is little wonder that many Jewish households never had the need or desire to own and operate their own personal transportation vehicles in Philadelphia. With new bus services initiated in the 1950s, Jewish residents could travel downtown for Wednesday shopping on one bus—either the Shopper Special lines along Summerdale Avenue and Large Streets or on the Boulevard Limited from the Broad Street subway. (Courtesy of Jeff Marinoff.)

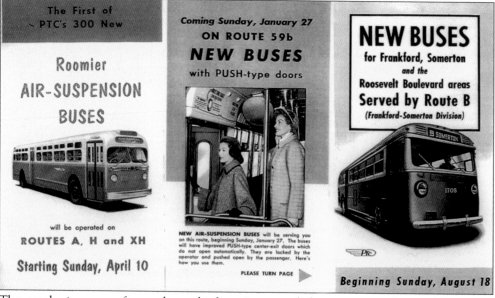

The emphasis on comfort and speed of service appealed to many residents of Northeast Philadelphia. New rolling stock of the Philadelphia Transportation Company included the jolly green buses, sporting the company's new paint scheme of white, green, and an orange stripe. Many people, young and old, enjoyed riding in the back of the bus over the rounded rear wheel hubs, with their arms perched on the window ledges, or on the long bench seat in the rear—a favorite of students. (Courtesy of Jeff Marinoff.)

Six

COMMUNITY SCHOOLS

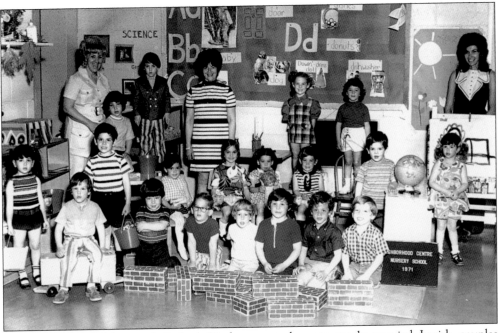

Northeast Philadelphia and Oxford Circle attracted many newly married Jewish couples after World War II, due to the area's excellent schools. As more new homes were completed, the demand for classroom space increased proportionally, and new schools were built to accommodate this upsurge in the school-aged population. A third branch of the Neighborhood Centre, which already had two branches downtown, opened at Bustleton and Magee Avenues in Oxford Circle in the 1950s. The center provided social, athletic, and educational programs for children ranging from ages 3 to 18. The new kindergarten attracted many children. Seen here, from left to right, are the following: (first row) Mark Rothenstien, Aaron Braverman, Steve Simon, Bruce Yeslow, Eileen Appel, and Jill Wolfson; (second row) Kip Kolosky, Ellisa Brown, and Merle Aaron; (third row) Jeff Goldberg, Joel Shpigel, Sharon Butler, Mike Schwartz, Ed Cohen, and Mitch Gersovitz. (Courtesy of Joel Shpigel.)

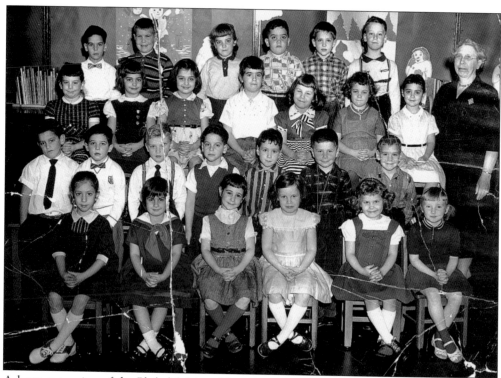

A large expansion of the Philadelphia public school system took place throughout the city in the 1920s. The expansion added more schools to District Nos. 7 and 8 in the Northeast. The schools were named for great Philadelphians and the regional sections of the city. The Laura Carnell School at Summerdale Avenue and Devereaux Streets educated children from first through sixth grades. The classes here were 70 percent Jewish and drew from Benner, Large, Shisler, Frontenac, Trotter, Levick, and Sterling Streets. (Courtesy of Joel Shpigel.)

Teachers were sometimes institutions all by themselves! As Oxford Circle expanded, the Gilbert Spruance School at Levick and Horrocks Street opened in the early 1950s. Local resident Herman Witman loved his work as a teacher, parent, and, later, grandparent—and it showed, as he influenced thousands of children to become mature, productive adults. (Courtesy of Alan Witman.)

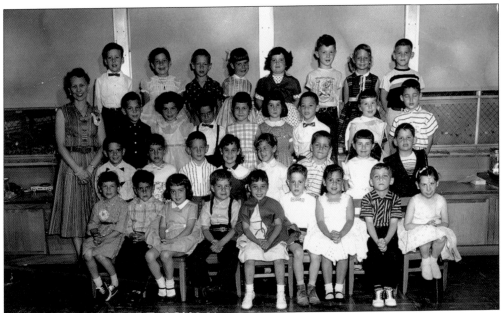

The J. Hampton Moore School at Summerdale Avenue and Longshore Streets opened in the Castor Gardens section of Oxford Circle in the 1950s, with programs for children in kindergarten through sixth grade. The children from Tyson, Algon, Loretta, and Unruh Avenues and Kerper, Brighton, Dorcas, and Knorr Streets received the benefits of personal attention from the many Jewish teachers in the school system at that time, as well as the benefits of the school's low classroom size of 30 to 35 students. Modular classroom were added as the school's student population grew. (Courtesy of Joel Shpigel.)

Principals promoted and placed in specific schools made a huge difference in the total school environment and actually became institutions all by themselves. Dr. Blumberg of the Solomon Solis-Cohen Elementary School, located at Tyson Avenue and Horrocks Streets, set an example for all his students to follow. This was the largest school, with adjacent athletic fields in Oxford Circle. (Courtesy of Marilyn Camel.)

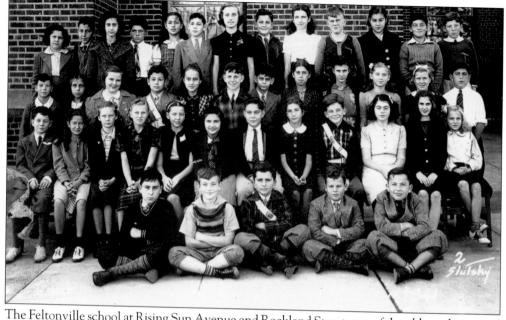

The Feltonville school at Rising Sun Avenue and Rockland Street, one of the oldest educational facilities, served the large Jewish population that arrived in the Feltonville section from the 1920s until the 1960s. The recess yard, where many school photographs were taken, was empty in the early 1960s, when the Philadelphia School District, with its high number of Jewish schoolteachers, made Rosh Hashanah and Yom Kippur citywide excused days off. (Courtesy of Marilyn Camel.)

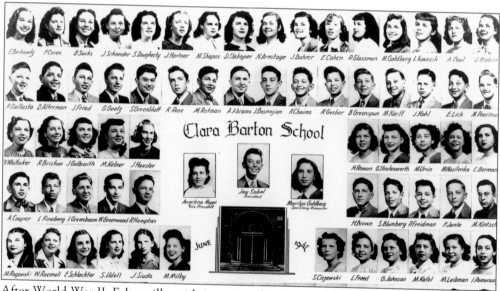

After World War II, Feltonville, with its various housing models, expanded due to additional homes built around Wyoming Avenue. The new families on Reach, G, Tampa, Rorer, Ruscomb, and D Streets provided ample reason for the school board to build the Clara Barton School at B Street and Wyoming Avenue, which went from kindergarten through eighth grade. The school was complemented by the addition of a branch of the Free Library and the nearby Feltonville recreation center. (Courtesy of Bert Greenspun.)

The area surrounding both sides of Roosevelt Boulevard, where the tall Sears Roebuck tower loomed as a landmark from 1920, contained a niche of homes known as Whitaker Acres, named for the Whitaker Mills family. The Thomas Creighton School at Tabor and Foulkrod Streets served the children from Mayfair, Garland, Smylie, Marley, Adams, Claridge, and Howell Streets, as well as those from Whitaker, Pennway, Mebus, Herkeness, and F Streets, on the other side of the boulevard.

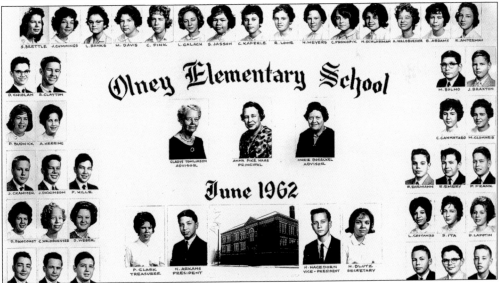

Students from Philadelphia School District No. 7 fed into Olney High School, including those from the Olney Elementary School, at Tabor Road and Waters Street. New homes were built in this area, before and after World War II, on the west side of the boulevard near the Brith Israel Synagogue. Children from the neighborhoods, which included Albanus, Westford, and D Streets, attended the Olney Elementary School, along with children from the popular apartment building on the northwest corner of Mascher Street and Roosevelt Boulevard, favored by incoming Jewish residents to the area. (Courtesy of Phyllis Budnick.)

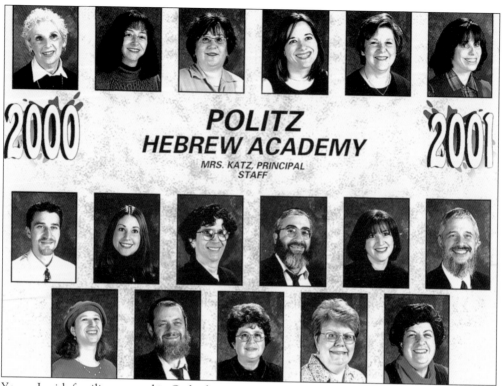

Young Jewish families, steeped in Orthodox practices, filled Rhawnhurst with a burgeoning family population that looked to Besie Katz for its educational needs. Katz, a product of the all-day Beth Jacob Jewish schools in Philadelphia, decided in the early 1980s to open a school focused on educational programs that would "continue the past." The Politz Hebrew Academy, with its committed cadre of professional educators, gives more than 300 students an intensive instruction in daily Judaism through multisensory and dynamic approaches. (Courtesy of Besie Katz.)

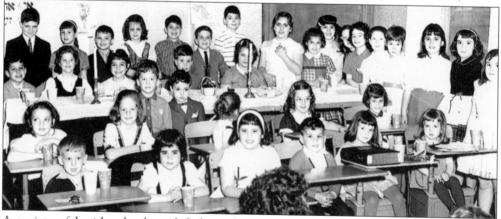

A variety of Jewish schools prided themselves on ideologies that appealed to the parents. The I. Peretz Workman's Circle School at 6500 Bustleton Avenue served as one of five such schools throughout Philadelphia in the 1960s. As its educational director, local resident Jacob Riz instructed the children of Holocaust survivors in *Yiddishkeit*—Jewish history, family cycle events, and the Yiddish language, at a time when Hebrew instruction was very popular. Ina Rubin (1962) is seen here in the back row, fourth from the left. (Courtesy of Joyce Rubin.)

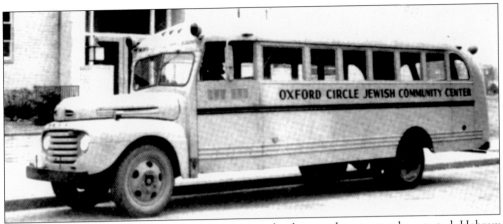

The upstart of many Northeast synagogues revolved around parents who started Hebrew schools in the basements of their new row homes. The Oxford Circle Jewish Community Centre, founded in 1948, bought school buses to pick its students up after school for classes in Jewish history, Bible, Hebrew, and religious customs. The United Synagogue of America's school curriculum revolved around a three-day-a-week program, which allowed children time to play with friends on off days. (Courtesy of the Oxford Circle Jewish Community Centre.)

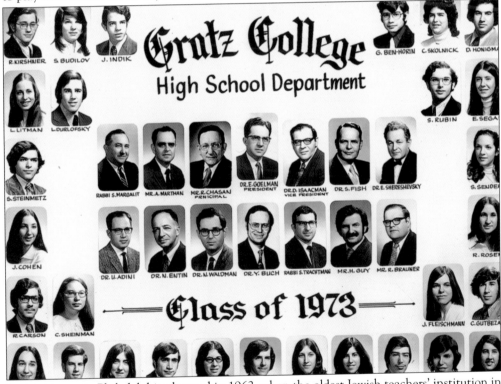

Jewish history in Philadelphia changed in 1962, when the oldest Jewish teachers' institution in the Western Hemisphere—Gratz College, founded in 1895—chose 10th Street and Tabor Road for its new educational facility. Gratz became a centrally located institution, serving the Jewish neighborhoods of Northwest and Northeast Philadelphia. The Julius Greenstone Hebrew High School, a 10-hour-a-week advanced program associated with Gratz, had a branch at Oxford Circle Jewish Community Centre. (Courtesy of Joyce Rubin.)

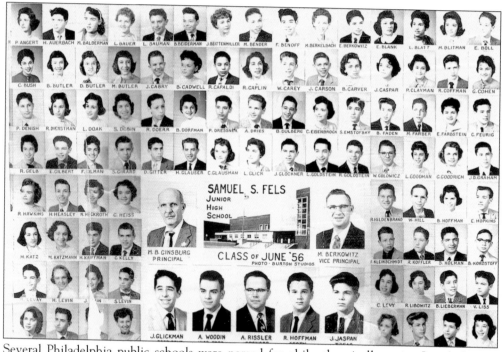

Several Philadelphia public schools were named for philanthropically active Jewish figures. Samuel Fels produced the all-purpose Naptha soap in Southwest Philadelphia. A new junior high school bearing Fels's name opened in Oxford Circle during the early 1950s at Devereaux and Langdon Streets, across from the Har Nebo Jewish Cemetery. The school attracted the best teachers in the system and served as a reason for many new Jewish couples planning to buy a home to move to the Northeast. (Courtesy of Sandie Davis.)

Sandie Davis, an Oxford Circle girl, enjoys a breezy spring day late in 1956 on the steps of the new, up-to-date Fels Junior High School. The new facility, with its modern architectural features, looked similar to college campuses, and provided an excellent learning environment. It had many labs, with plenty of cross-ventilation, in all of its classrooms, and was within walking distance of many students. (Courtesy of Sandie Davis.)

Wilson Junior High School at Cottman and Loretto Streets in Northeast Philadelphia started a tradition called "move up day," featuring balloons, clown makeup, and a parade on Cottman Avenue. The tradition dates back to the 1920s, when the school ran from 1st grade through 12th grade, since the area was sparsely populated. That changed with the opening of additional elementary schools in Oxford Circle and Rhawnhurst, and the building of the new Northeast High School, which opened in 1956. (Courtesy of Marsha Berman.)

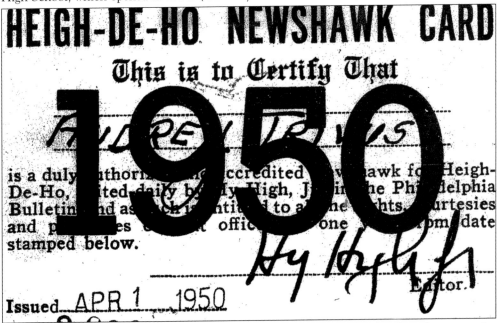

From across the city of Philadelphia came spectacular creative high-school-aged writers, who ran the school newspapers and yearbook committees. The old *Philadelphia Evening Bulletin* newspaper sponsored the Heigh-De-Ho Club, which allowed students to write articles on many subjects for publication. This prestigious card was the envy of many girls in high school. (Courtesy of Audrey Sorens.)

The 1920s ushered in a new climate and thinking for the high grades in the Philadelphia public schools. Olney High School drew students from many feeder schools and went from 9th grade through 12th grade. Due to location in the city of Philadelphia, secondary schools including Abe Lincoln offered varied programs and when Northeast High School on Cottman Avenue opened "forced transferred" teachers and students alike to ease over crowded classes.

Within a 15-year period after World War II, Philadelphia built three state-of-the-art high schools in Northeast Philadelphia. The last one, George Washington, was built in 1961 at Bustleton Avenue and Verree Road, and served the young adults above the Pennypack Creek to the far Northeast. The school ran grades 7 through 12 in one school. Northeast High was so overcrowded that some of the school's students were allowed to take courses at Washington and remain there until graduation.

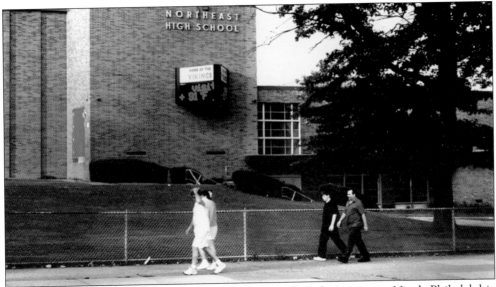

The old Northeast High School at Eighth Street and Lehigh Avenue in North Philadelphia was originally an all-boys school for manual trades. Changing the school's name became a hot issue, and the city council decided to rename old Northeast High as Edison High. The trophies and showcases of medals and honors were transferred to the new Northeast High School at Summerdale and Cottman Avenues in 1956. The campuslike school had many athletic fields and modern classes.

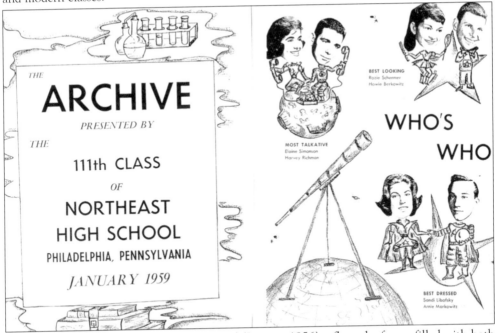

The first yearbook of Northeast High School (January 1956) reflected a future filled with both hope and anxiety about the times Americans lived in. The students lived in a time when air raid drills were still practiced, and the Y bus that ran on Cottman Street had to stop until the all-clear was sounded, and yet their yearbook honored the same old traditions, with awards of best-looking and best-dressed students.

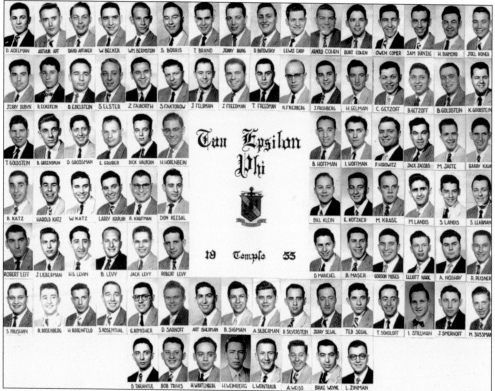

Jewish fraternities and sororities and clubs at high schools and colleges in Philadelphia connected students to a culture that was found in all its neighborhoods, regardless of social and economic class—a culture of comrades. The fun activities provided a release from academic tensions for all its members, and lifelong friendships evolved from gatherings like this one sponsored by Tau Epsilon at Temple College in 1955. (Courtesy of Adele Greenspun.)

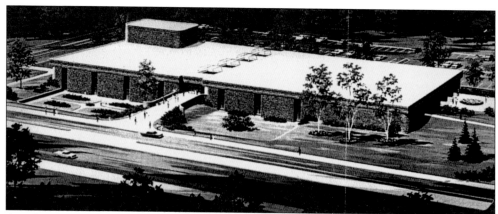

Another way to express community unity was found in social, athletic, and cultural programs in the Jewish Community Centers, sponsored by the former Jewish Ys. As Jews migrated to the city limits of Northeast Philadelphia, a new, modern facility on Red Lion and Jamison Roads opened to the public in 1975. Clubs were formed, and all age groups enjoyed the Olympic-sized swimming pool. (Courtesy of the Jewish Community Centers.)

Seven

FAVORITE PLACES TO GO

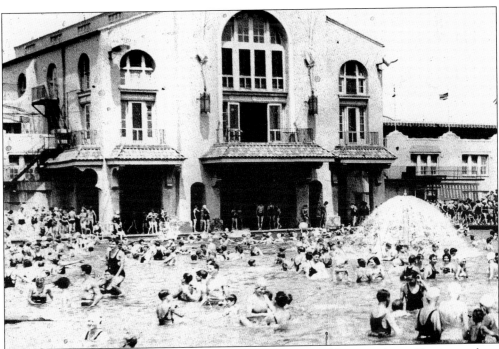

Everyone's childhood is filled with memories of adventures and favorite places. Getting to those places was usually half the fun, and some neighborhoods were lucky enough to have a host of places unique to their area. The name "the Great Northeast" was coined by Bernard Gimbel on his famous landmark, Gimbels department store, and is often laughed at by nonresidents of the area, who still wonder just what is so great about the Northeast. For those of us fortunate enough to grow up in the area, there was plenty to see, eat, and do. The Boulevard Pools at Tyson Avenue and Roosevelt Boulevard opened in the late 1920s and provided children a reprieve from the summer heat with four large swimming, wading, and diving pools, complete with a beach, arcade, picnic grove, and other resortlike amenities. Harry Blatstein bought this great Northeast asset in 1948 and ran it until its closing in 1976. (Courtesy of Bart Blatstein.)

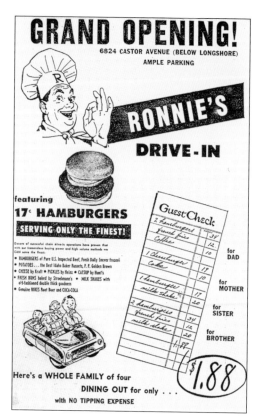

Ronnie's on Castor Avenue, similar to Arnold's on the famous *Happy Days* television program, opened in late 1957. The off-street restaurant, founded by local real estate icon Harry Toben, addressed the need for a modern and up-to-date place for youngsters and families to gather. (Courtesy of Harry Toben.)

Another Castor Avenue landmark was Lenny's Hot Dogs, founded by the South Philadelphians Max and Ida Kravitz, who turned the 1935 business over to their son, Lenny. Lenny opened three other outlets. The attraction of hot dogs, fishcakes, and cherry soda allowed parents to recall their own childhoods from many sections of the city and continue the tradition with birthday parties. The Polar Cub hamburgers on Cottman was a competitor. (Courtesy of Betty Anne Gray.)

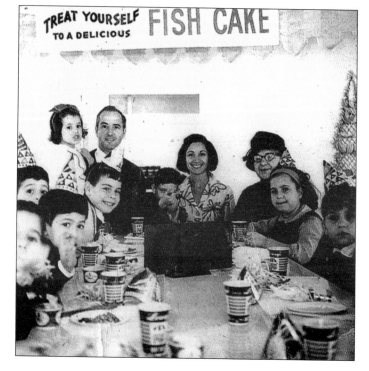

66

Regionalism came to the Northeast in the 1960s. With the opening of the Roosevelt Mall in 1962, Lit Brothers, Gimbels, Kleins, and E. J. Korvettes, people no longer needed to go downtown for services. The Orleans movie theater also opened at Bustleton Avenue and Bleigh Street. The area's first multiscreen cinema with first-run movies, the Orleans entertained everyone from the Northeast and was easily accessible by bus or car, with a large parking lot to handle holiday crowds.

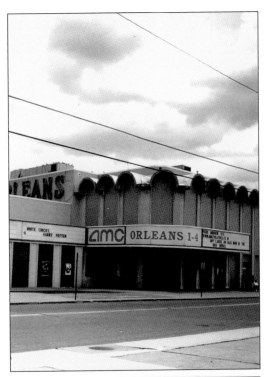

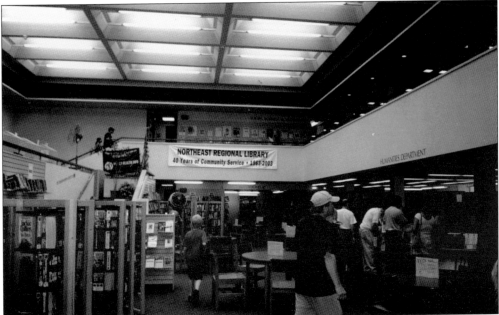

The concept of the Northeast Regional Library, separate from the very impressive downtown institution on the Benjamin Franklin Parkway, took shape in early 1963 at Cottman and Bustleton Avenues. Local resident Harry Kapenstein and Phyllis Kaufman directed the library from its inception. The term interlibrary loan went hand in hand with the collegelike facility, with its neat cubby sections available for deep thought. Everyone remembers the large round tables in the center and the turnstile used to regulate traffic.

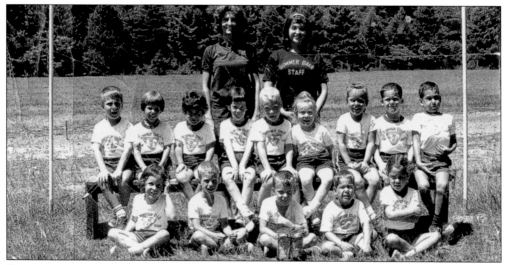

Summertime meant summer camp and a chance to meet and make new friendships. The Summer Dale camp outside Northeast Philadelphia in Eddington allowed children of different age groups to expand their childhood on 40 acres of woodlands. Swimming, horseback riding, and archery were just some of the activities enjoyed by the children. It was an age-old tradition among Philadelphia Jewish families to "take a vacation from their children" and send them to camp during the summer. (Courtesy of Ellis Gray.)

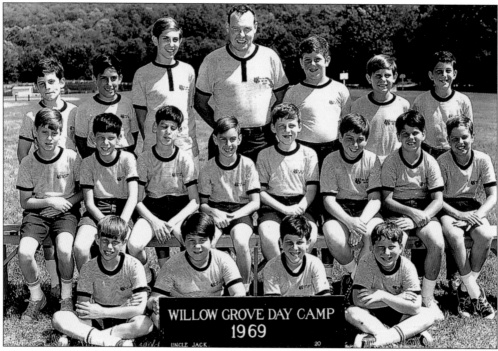

Many a child with lunchbox in hand waited at various corners in Northeast Philadelphia for school buses to take them to their favorite summer camp. Children were required to follow a dress code and line up with their favorite camp counselors at the Willow Grove, founded by Howie Zeitz and Marvin Domsky in the mid-1950s on the old Lichenstein farm. (Courtesy of Ellis Gray.)

Philadelphia hosted the Boulevard Day Camp in the far Northeast on Poquessing and Knights Roads in the late 1940s. Herman Witman and Bernard Auerbach, both Philadelphia schoolteachers, ran the facility under the watchful eye of the Philadelphia Health Department. Herman anticipated owning Boulevard Pools originally and later did own Camp Kweebec on Route 29 in Swenksville, Pennsylvania. (Courtesy of Allan Witman.)

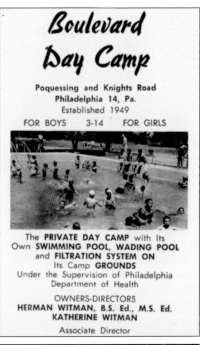

Boulevard Day Camp

Poquessing and Knights Road
Philadelphia 14, Pa.
Established 1949

FOR BOYS 3-14 FOR GIRLS

The **PRIVATE DAY CAMP** with Its Own **SWIMMING POOL, WADING POOL** and **FILTRATION SYSTEM ON** Its Camp **GROUNDS** Under the Supervision of Philadelphia Department of Health

OWNERS-DIRECTORS
HERMAN WITMAN, B.S. Ed., M.S. Ed.
KATHERINE WITMAN

Associate Director

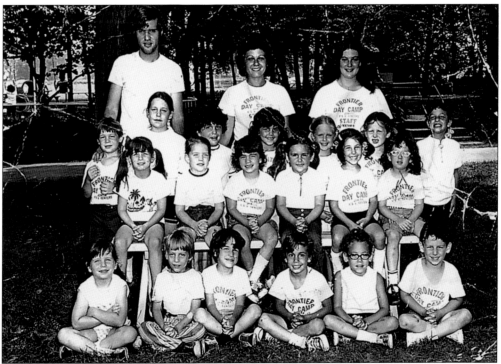

Competing to recruit Northeast children to a multitude of summer day camps became an annual labor of love for the institutions that ran these wonderful places. New help had to be acquired every year, and when the children grew older, a paid junior camp counselor position was the envy of the boys and girls alike. The Neighborhood Centre at Bustleton and Magee Avenues ran Frontier Day Camp. (Courtesy of Marsha Berman.)

Sports played a big part in the development of Jewish children in Oxford Circle. The social skills and athletic abilities associated with trying out for team leagues or "choose-up" games required one's full attention. The acceptance level of each individual as a team player provided the football players—Norman Millan, Ed Edelman, Jack Kapenstein, and Monty Shapiro—lifelong skills from palling around at Tarken and Max Myers Playgrounds. (Courtesy of Jack Kapenstein.)

Arthur Davis, a tall Jewish kid from Oxford Circle, had both the physique and the skills to play many sports, but he enjoyed basketball the most. The addition of lights at Max Myers, Jardel, and Rhawnhurst Playgrounds made night leagues a reality in the 1960s. Mark Sheinson, Alan Lakernick, and Glen Kamen played in the Howard Spivak League. (Courtesy of Jack Kapenstein.)

Burholme Park at Central and Cottman Streets, on the border with Elkin Park and Jenkintown, attracted thousands of people on a daily basis to its large picnic grounds and park activities. The added attraction of on-site parking made for a fun family outing. Leisure time was well spent in a hammock, or in walking over to the driving range to hit golf balls in competition for an ice-cream cone. (Courtesy of Faith Richman.)

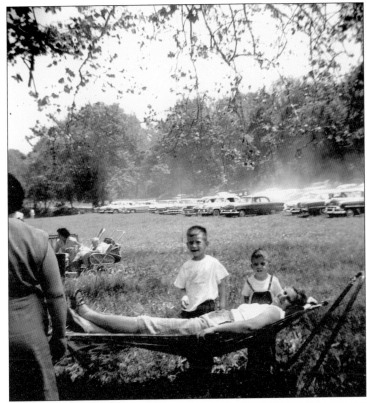

Teachers and students interacted on the field at Northeast High on Cottman Avenue as the new school opened in the late 1950s. The educational complex included a huge football field, several baseball diamonds, and many basketball courts on its 10-acre site. Hal Kessler from Lincoln High received his marching orders to teach at Northeast High in the late 1950s and looked forward to playing in the student-versus-teacher baseball games. (Courtesy of Hal Kessler.)

Sears, America's largest retail catalog merchant in the 20th century, built its mammoth-sized eastern headquarters under the direction of Lessing Rosewald in 1920. This regional landmark also served the children from Pennway Street and Whitaker Avenue as an ever present wristwatch when they played on the grassy fields inside Friend's Hospital, America's oldest mental institution, founded in 1813. For other Northeast residents, the Sears building meant that you were near home. The building was imploded in 1999, and many childhood experiences are now only memories. (Courtesy of Allen Meyers collection.)

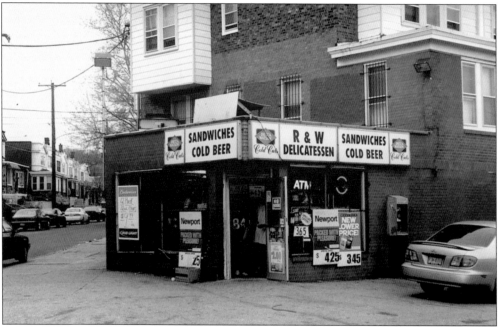

R & W Delicatessen, located at the three-way round point intersection of F Street, Roosevelt Boulevard, and Herkeness Street, provided an instant parking lot for patrons. Young adults brought dates here and were greeted at the door with the pleasant smell of Jewish pickles in the air. Memories of those thick corn beef sandwiches on fresh rye bread are etched in our collective mind to this day! (Courtesy of Allen Meyers collection.)

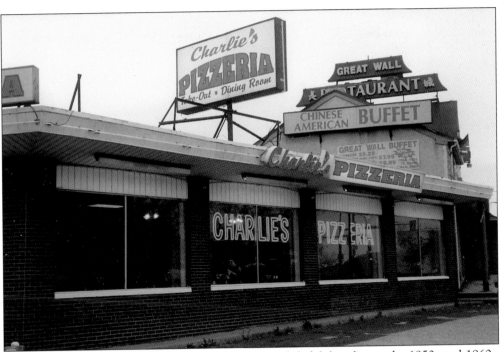

Drive-up restaurants were all the rage in Northeast Philadelphia during the 1950s and 1960s. Friends arrived piled into late-model cars with split windshields and drive shafts on the steering wheel column. Charlie's Pizzeria, a favorite hangout for many local and Oxford Circle teenagers, provided drive-up parking off Roosevelt Boulevard near Sears. We can all remember the piping-hot tomato pizza pies that burned the roof of your mouth, and the red-colored birch beer we drank to cool down.

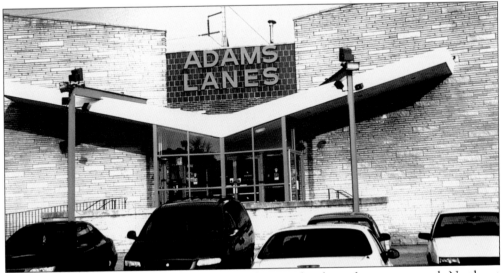

Nothing beat gathering a whole crew of friends to go bowling after a great meal. Northeast Philadelphia had four popular bowling alleys—Adams Lanes, Oxford Lanes, Cottman Lanes, and Boulevard Lanes—where everyone learned to hold a heavy bowling ball with two hands and compete for how many gutter balls you could throw. The red bowling shoes rented for 25¢.

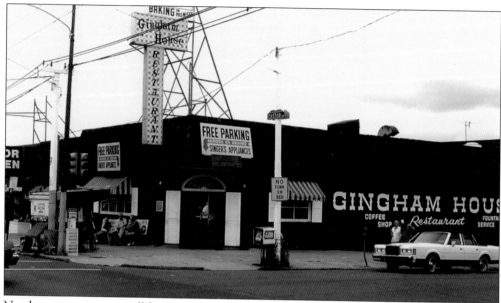

Northeast eateries are well known for their hospitality at all hours of the day. The Gingham House on Castor Avenue and Hellerman Street provided neighbors and shoppers with hot meals of chopped liver and matzo ball soup year-round. The most popular dish was well-done brisket and kasha and bow ties, with gravy on the side if you preferred some. Former Strawberry Mansionites called this place home and gathered here to talk about the old neighborhood. (Courtesy of Allen Meyers collection.)

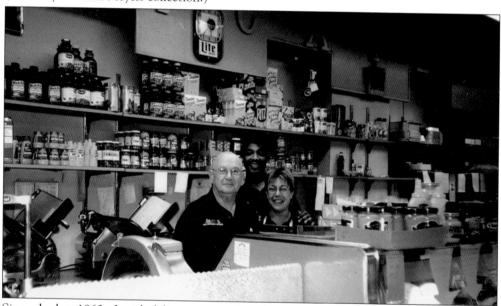

Since the late 1960s, Jewish delicatessens and sit-down restaurants have been rated against the taste, smell, and quality of the food and service provided by Jack's Restaurant, located in Bell's Corner at Bustleton Avenue and Tustin Street, and owned by Alan and Eddie Mutchnick. Meals start with a wooden bowl of assorted Jewish pickles and a very extensive menu, created when Jack's existed on Wadsworth Avenue in West Oak Lane. Jerry Newman (a 32-year veteran), Byron Waters, and Mickie Danglo are ready to serve you.

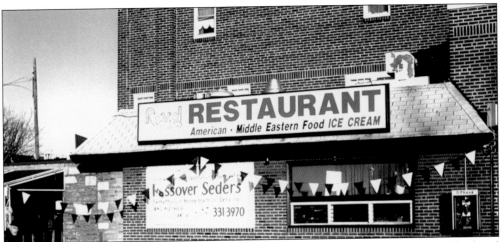

The former Tyson Grille on Bustleton and Tyson Avenues played a vital role in neighborhood affairs from the 1950s until the 1980s. The fare was freshly made ice-cream, waffles, and dishes that rivaled Kach's Ice Cream Shack on Roosevelt Boulevard. Ruth Kanas, a longtime waitress, made sure all the kids in the neighborhood who ate there finished their vegetables. The restaurant later became the Royal, which was run by a local cantor and offered to-go Passover seder meals. (Courtesy of Allen Meyers collection.)

The early 1970s ushered in a new era in Atlantic City, as the old Jewish boardinghouses faded in time and casino gambling from Las Vegas came to town. By 1978, whole buses arrived from Kushner's Wide World of Travel at Bustleton and Cottman Avenues, which ran very good packages with food and playing money incentives. Esther and Leonard Meyers played all night on $20 in quarters.

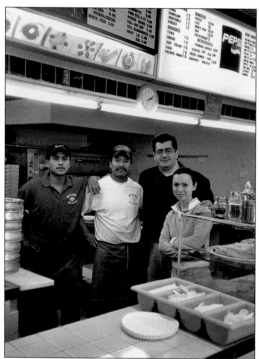

A kosher food establishment that observed the Sabbath came to Castor Avenue in the 1980s, along with the opening of the Red Dragon Chinese restaurant and the Kosher Grocer. Holy Land Grill (meat) and Holy Land Pizza (dairy), owned by Moshe and Tali Sabag from Jerusalem, use only *glatt* (strictly) kosher dairy and parve ingredients and include a make-your-own falafel salad bar, complete with real Israeli vegetables. The community support is obvious, as the restaurant is fully packed after sundown on Saturday nights.

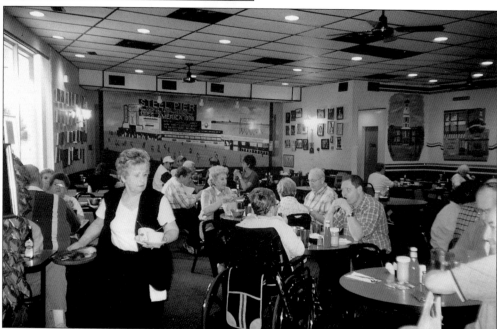

Casino Deli on Welsh Road east of Roosevelt Boulevard, owned by Manny Rosen, has been a haimish place to eat and meet old friends since 1980. Near the old E. J. Korvette's shopping center, the deli attracts people from the nearby homes and apartment buildings. The homemade recipes seem to taste even better since Manny commissioned someone to paint a mural of street scenes from the old neighborhoods of South Philadelphia, 40th and Girard, and Strawberry Mansion.

Eight

SHOPPING DISTRICTS
AND CENTERS

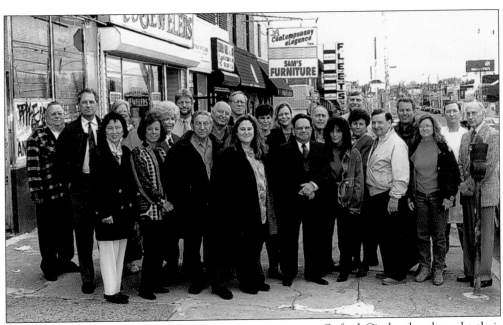

When the citywide Jewish population began to migrate to Oxford Circle, they brought their former stores with them to Castor Avenue. Space for stores, separate from the row homes, was allotted by community homebuilders Max and Hyman Korman up and down and both sides of Castor Avenue. Stores from South Street, 40th and Girard Avenue, 31st Street in Strawberry Mansion, and Marshall Street picked prime locations. Everything imaginable could be bought, including clothing, shoes, records, dresses, baked goods, kosher meat, and delicatessen foods. Warren Matz, a local resident, started a jewelry store in the 1960s, based on his apprenticeship under Harold Grobfsky. Here we see the Jewish merchants gathered for an anniversary shot in the 1990s. (Courtesy of Warren Matz.)

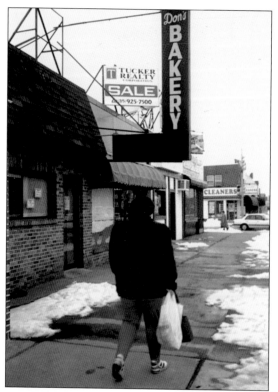

Don's Bakery, a local favorite on Bustleton Avenue since 1952, was started by Sam Don, a Holocaust survivor, and his wife, Shirley. They started at the bakery on Third and Poplar Streets and later took over another one at 900 North Marshall Street before building the Bustleton Avenue business. Don's, known for its loaf cakes, raisin challah, and twin filled danishes, treated everyone with dignity and respect.

The Lipkin family of bakers goes back to Jacob and Rose from Poland, who started out on Marshall Street in the 1920s. Jacob's son, Abe, opened his bakery at Fourth and McKean after taking over from the Lipton family in the 1950s. The Lipkins moved to Castor Avenue in the late 1960s, and to this day, Abe and Miriam Lipkin's sons, Mitch and Jerry, maintain a link with the Philadelphia Jewish community. Business has changed as customers have become more concerned about their health, but while many similar establishments have disappeared, Mitch continues to serves fresh potato, rice, and kasha knishes and his famous cinnamon nut twists, along with his delicious rye bread, bagels, and danishes at his location on Castor Avenue.

The Weiss siblings, Yossi, Abraham, and their sister, Miriam, started their adventure in baking in Brooklyn, New York, on 13th Avenue between 50th and 51st Streets, with their mother's recipes. The Hungarian bakery is closed on Saturdays for the Jewish Sabbath. The old-world cheesecake received a new face and now comes in cappuccino, peanut, and black forest flavors. The poppy seed wraps (cocosh) and the wide assortment of cookies are all world class. (Courtesy of Anna Peryman.)

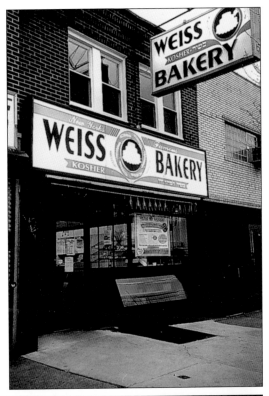

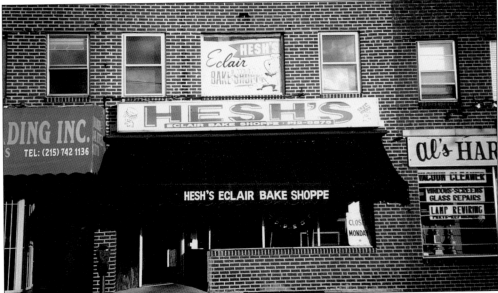

Heshie Braverman, a former head baker, decided to find his own niche in 1960 and started Hesh's Eclair Bake Shoppe in the 7700 block of Castor Avenue. The famous eclairs, filled with Bavarian egg cream, along with ice-cream cakes, have attracted a large following in the Rhawnhurst section. The rich butter cream topping found on the bakery's brownies, fancy cupcakes, and tempting loaf cakes is legendary as the Moishe Addison bakery in the Somerton section of the Northeast. During the holidays, the customer line stretches down Castor Avenue.

For some truly good delicatessen food, try Moe's on the 7400 block of Frankford Avenue, where the sandwiches served in the dining room extend off the platter. The neatly kept double store has served the Mayfair section for decades and its booth service has always been first class. The business, under renovation in 2004, offers a catering menu with a wide assortment of trays for all occasions.

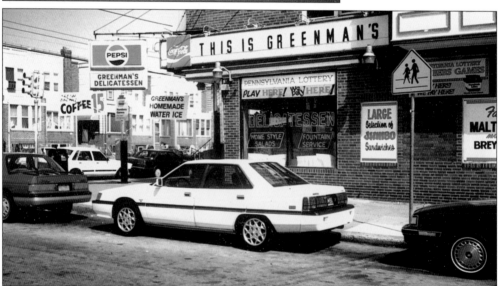

For the best real milkshake and the "monster hoagie," come to This is Greenman's, a deli at Robbins and Levick Streets. Alexander and Claire Bicht, both from Russia, married in 1948, and opened their first deli at Eighth and Ritner Streets. The couple migrated to the Northeast in 1949 and lived upstairs from their deli there. Their sons, David and Norm, grew up in the business and recall listening to a bell that customers rang downstairs to call for assistance. David now runs another location of the restaurant on Grant Avenue.

Abe and Nettie Gardner, from Seventh and Wolf Streets, migrated to Castor and Princeton Avenues in 1955. Customers gathered every Sunday morning to "take a number" and then place their usual orders of Nova (smoked) or regular lox, kippered salmon, whitefish, and bagels, along with sweet onions, cucumbers, fresh tomatoes, and black olives by the pound. The Gardners' son, Mitch, is a smoked-fish specialist and runs the operation on Bustleton Avenue above Bleigh Street with his wife, Rita.

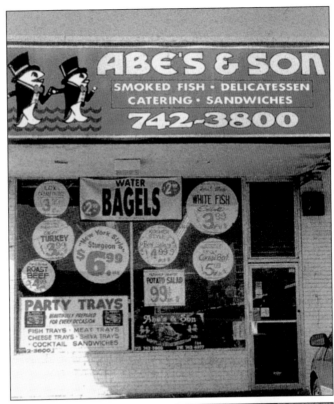

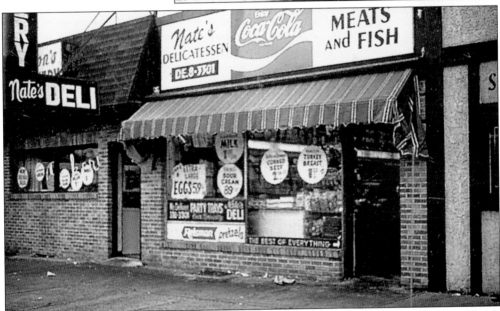

Lou's, a small popular deli on Bustleton Avenue and Longshore Street, later became Nate's and included a grocery store. The chopped herring and liver were all homemade. "Food for particular people" was their motto, and Nate's added whitefish salad and lox blended with orange or white cream cheese as a new generation called for convenience in the early 1970s. Of course there were rows of Philadelphia Frank's soda, especially Black Cherry Wishnick.

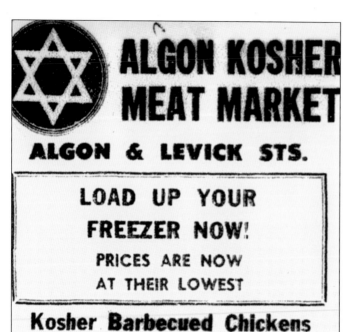

In the 1950s, the Philadelphia Jewish community supported 455 kosher butcher shops. Algon Kosher Meat Market at Levick Street and Algon Avenue added a kosher barbeque chicken line, visible from its front picture windows turning on a rotisserie, to offer more convenience for their clientele. Everyone in the immediate Oxford Circle area walked over to pick up their orders. (Courtesy of Allen Meyers collection.)

Where the 6700–7000 block of Bustleton Avenue had five kosher meat markets during the 1970s, today there are only two. Simon's and Bustleton Kosher Meats cater to a declining Jewish population. Simon's cuts and trims meat the old-fashioned way, adhering to a *glatt* (very strict) regiment of rules for meat distribution. The store also carries canned and frozen goods from Israel.

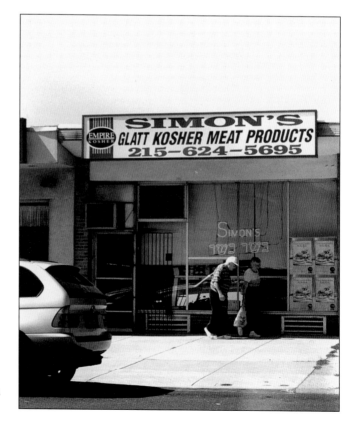

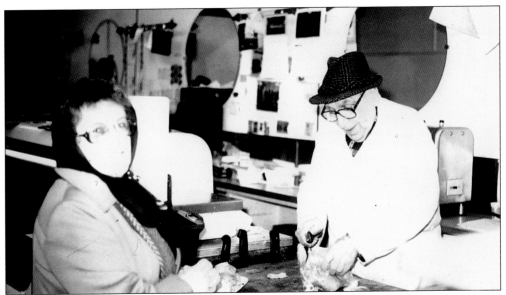

The old-fashioned kosher butcher—a tradesman and customer service ambassador to the community—prided himself on being very pious and honest. Customers watched the butcher cut and trim the meat. Oscar Waldman, an Oxford Circle resident, in later years moved his business from Strawberry Mansion to Overbrook Park on Sherwood Street and Haverford Avenue. Neighborhoods change, but Waldman cut meat right the first time for every customer. (Courtesy of Allen Meyers collection.)

Louis Skaler moved to Oxford Circle from 40th and Ogden Streets in 1952 and opened a large, white-tiled, spotlessly clean meat market. In addition to selling only prime kosher meats, Louis added luncheon meats from the Sandlers' kosher salami factory in Strawberry Mansion.

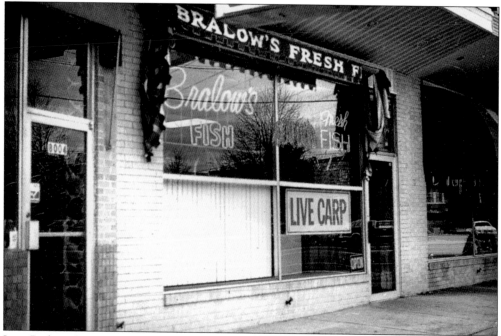

Lou Bralow from South Philadelphia opened his fresh fish market on Ninth Street and Washington Avenue in 1930. Lou's son, Donald, and his wife, Marion, migrated to Rhawhurst in 1960 and opened Bralow's Fresh Fish at 8000 Bustleton Avenue. Carp, shad, pike, and whitefish are the most popular. The fish known in Yiddish as *gefilte* is translated as "stuffed fish." Eastern Europeans ground fish meat and stuffed it into the skin for flavor and presentation every Friday night. A third generation of the family, Marc Bralow and Al Antonelli, now runs the store.

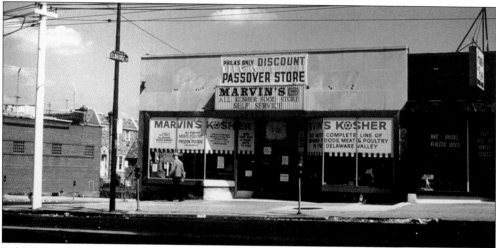

Rabbi Ephraim Yolles explained to the author that in the late 1950s, Jewish women found the convenient, prepacked meats at new supermarkets very appealing, which accounted for the decline in kosher butchers during that period. A resurgence of interest in kosher food for year-round use came full circle a generation after the end of World War II, when the baby boomers were ready to start their own families. Big freezers available in the 1980s allowed a return to kosher frozen foods, and Marvin's opened a store on the 6400 block of Castor Avenue.

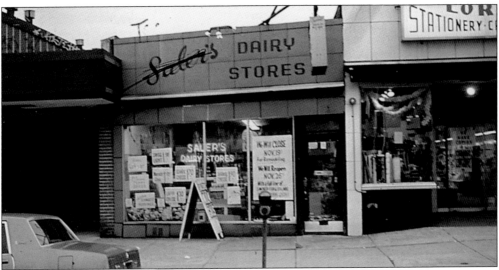

Saler's Dairy—plus some 45 butter and egg stores—opened in Philadelphia after World War II. The Saler's name stood for quality, and each wooden case of cheese was given to each lady. Harold Saler, the son of the founder, expanded the business to include lekvar—a prune filling for the three-cornered cookie delights known as hamantaschen, which are eaten during the celebration of Purim in the springtime. (Courtesy of Allen Meyers collection.)

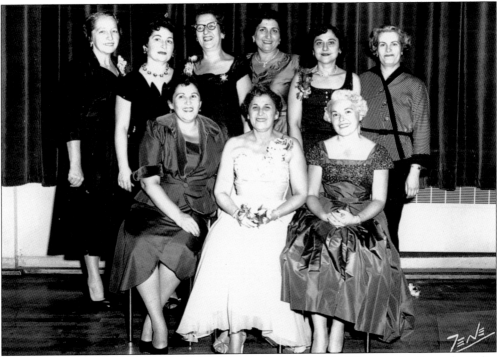

The ladies of the 6700 block of Castor Avenue rallied around the Waxman family at the Solis-Cohen PTA. The families grew closer as their children went to school together. During the late 1950s, this block changed when real estate agents and builders ripped up large lawns, created stores on them, and converted these homes into investment properties. The original neighbors sold their homes and moved into Rhawnhurst.

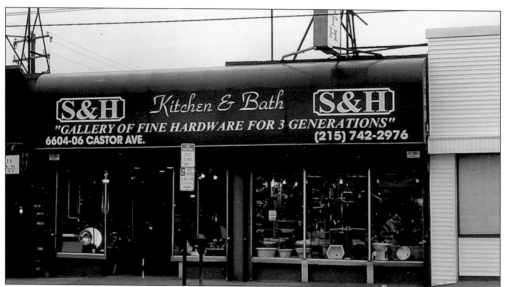

In 1980, Harold Stern expanded his business and opened up two stores after selling 6624 Castor Avenue. A premier kitchen and bath shop opened farther down Castor Avenue toward Magee Avenue, where shower doors, mirror vanities, and modern medicine cabinets were displayed to buyers. The old stores along the avenue, including Rexall Drugs, Lax's men's wear, Lenny's Hot Dogs, and Castor Movies were all gone. The Continental diner, Fleets boys wear, and a new Drug Emporium opened in their place.

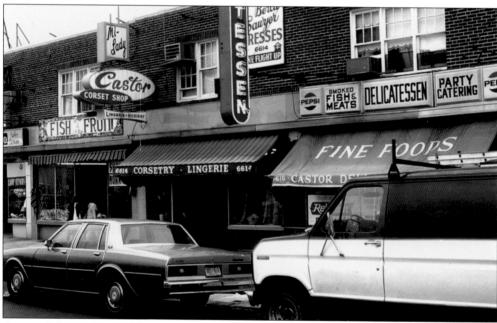

A typical day in the neighborhoods during the 1970s included long walks down the 6600 block of Castor Avenue to browse in the many display windows. The entire shopping district was occupied with door after door of shops, including Mi Lady Corset shop, the fruit and fresh fish store, and the Castor Deli. All the second-story apartments were rented out as well, with some businesses, such as Bertha Sawyer Dresses, existing there as well.

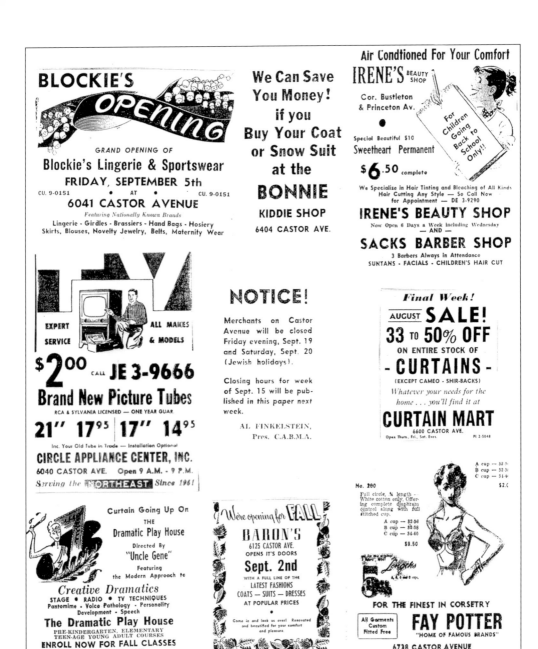

The hottest newspaper of 1952, the *Northeast Weekly*, captured the momentum of the era with a full-page advertisement for many Castor Avenue merchants. The whole shopping district decided to close in honor of the Jewish holidays on September 19 and 20, 1952. (Courtesy of Bob Skaler.)

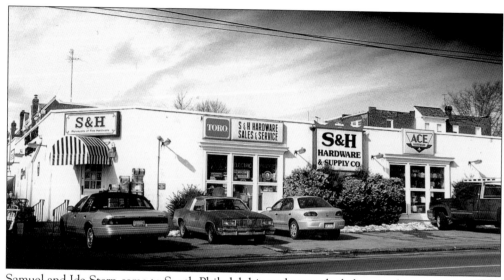

Samuel and Ida Stern came to South Philadelphia and opened a bakery in the second decade of the 20th century. They migrated to 40th Street and Girard Avenue in 1935. In 1953, Sam and his son, Harold, went into the hardware business and opened up a store, S & H, in Oxford Circle at 6624 Castor Avenue, selling screen doors; paint; and plumbing, electrical, and roofing supplies. The store sold Lionel trains year-round with the help of Harold's sons, Herb and Stuart.

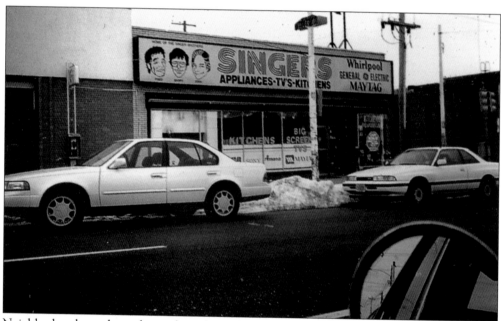

Neighborhood merchants knew the value of knowing their customers, and this loyal customer base followed Abe Singer when he moved his appliance business from 6013 to 6413 Castor Avenue. Abe made the money to buy these properties from a summer selling hot dogs on the boardwalk. Abe's sons, Fred, Stan and Barry, grew up in the family store, and their mother, Gertrude, instructed them to talk with the customers as well. Eventually, the second generation of the Singer family migrated across the street to a double store at Castor Avenue and Hellerman Street in 1963 to sell more appliances.

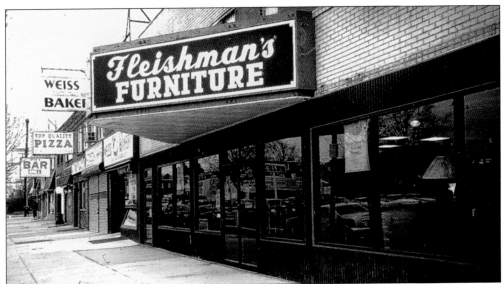

The Fleishman furniture people originally set up shops in two locations on Castor Avenue, which contained a vast number of competitors. When the Castor Movies shut down, Milt Fleishman moved the business to larger quarters in the 6600 block of Castor Avenue and served another generation of customers. Al Rubin served the lower end of the avenue. In those days, even upholstery merchants, such as Al Behner and Good Luck Home furnishings from the 7300 block of Castor Avenue, sold mattresses and other home items.

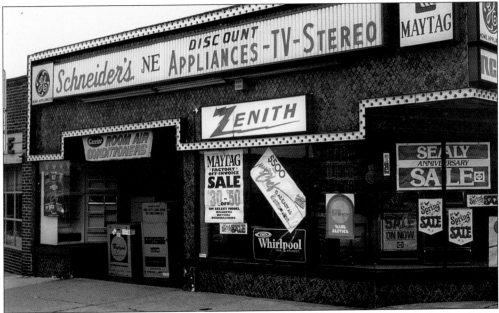

Schneider's, formerly of Strawberry Mansion, entered the appliance business in the late 1940s with electric washing machines sporting top wringers. The new television age ushered in the era of sidewalk viewing of favorite shows by local residents. The move to the 6500 block of Castor Avenue in Oxford Circle included the addition of stereos made by Zenith and RCA. Maytag, General Electric, and Whirlpool jumped into the home-use dryer market before the Silos came along.

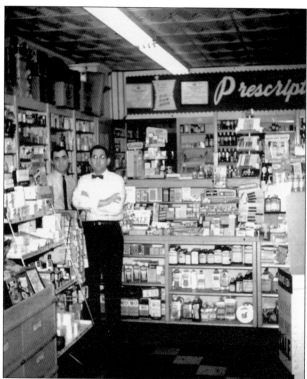

Philadelphia turned out many druggists from the Temple University School of Pharmacy. Irvin Silverstein did his work at Temple in 1948 and practiced in South Philadelphia until he moved to Ramon Drugs on Bustleton Avenue in 1954. The cadre of druggists in the Northeast included Manus, Stanwood, Meltzer, Gold, Seltzer, Suburban, Shelly, Gene's, and Rosen. (Courtesy of Betty Silverstein.)

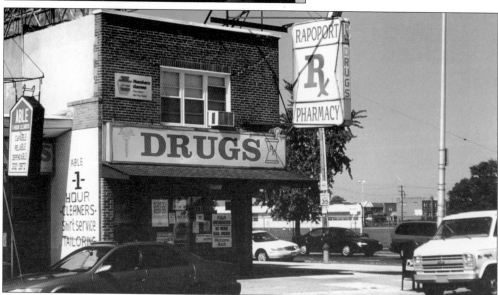

Howard and Florence Rapoport, a husband-and-wife team, started out in South Philadelphia and in 1952 opened Rapoport's, a drugstore at Tyson and Bustleton Avenues. In those days, you needed many hands to operate the soda fountain and to compound stomach remedies, cough syrup, and cold capsules. The shelves had to be kept neatly stocked as well, with sundries such as calamine lotion, Phillip's milk of magnesia, and Coppertone sun lotion. Local doctors, whose patients patronized the local druggists, included Sid Brenner, Al Nemez, Milt Freedman, and Lee Shmokler. Jeff Moskowitz now owns Rapoport's.

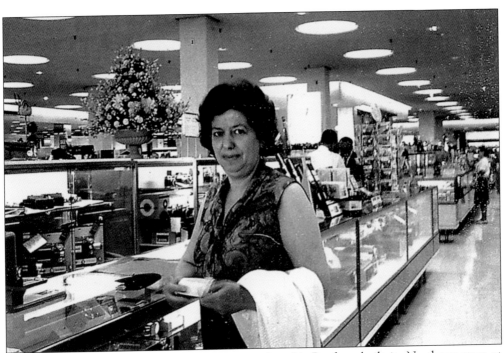

Downtown shopping trips became unnecessary when Lit Brothers built its Northeast store at Castor and Cottman Avenues on what was once open prairie land. The store joined Gimbels, located at Cottman and Bustleton Avenues. Two well-known banks, First Trust and PSFS, opened regional branches at Cottman and Castor Avenues as well. Shoppers also had the Penn Fruit, Food Fair, and Pathmark supermarkets. They could stop for a quick bite to eat at Polar Cub charcoal burgers or sit down for a meal at H & H on Large Street. (Courtesy of Linda Waxman.)

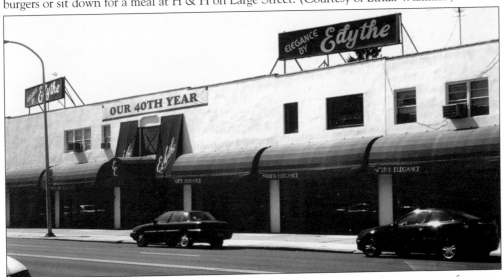

Elegance by Edythe (Zwick), located on the 6900 block of Bustleton Avenue, grew from two stores to the entire block, offering handbags, shoes, hand-sewn ballroom dresses for formal affairs, and long gowns for New Year's Eve parties. The quality of these items is unmatched anywhere in the city, and Edythe is known for her sale in which customers buy an item and get the second for $1.

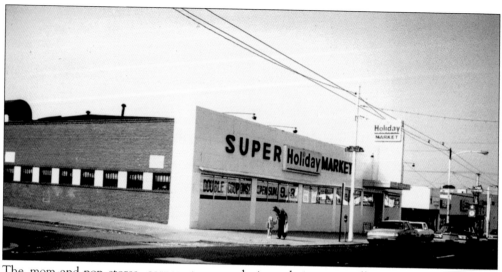

The mom-and-pop stores, corner stores, and giant chain stores all coexisted in Northeast Philadelphia, unlike in any other section of the city. The various levels of income, taste, and sophistication provided an instant premier market. The 1964 opening of the first self-service supermarket in Philadelphia by the Manusov family of West Philadelphia led to further acceptance of large shopping facilities for weekly grocery purchases. The familiar Holiday Supermarket at 6400 Castor Avenue is sorely missed.

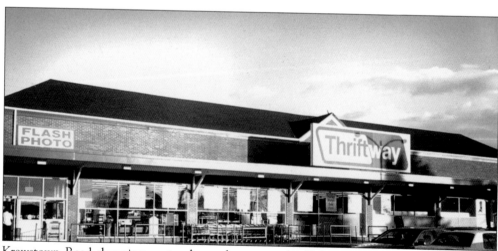

Krewstown Road shopping center, better known as the K-Center, included a host of stores in this first successful neighborhood strip mall setting, with plenty of parking below Grant Avenue. The mall had several anchor specialty stores, such as Spain's Card Shoppe and Cooke's Fine Gourmet Foods, and also included the huge Pickwell (later Thriftway) supermarket, with more than 50,000 square feet of space.

Nine

NEIGHBORHOOD SYNAGOGUES

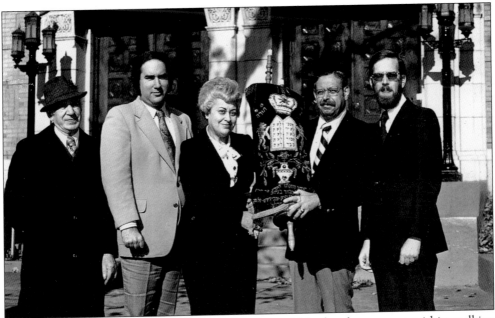

The hallmark of any Jewish neighborhood is the neighborhood synagogue within walking distance of its residents. Northeast Philadelphia supported 45 synagogues at its peak in the 1970s. The count of the Jewish population is always a little fuzzy and ranges from 120,000 to as high as 160,000. The unaffiliated ratio of 40 to 60 percent accounts for this disparity. The formation of a Jewish neighborhood is usually centered around young Jewish couples with young children ready for Jewish education. The oldest Jewish synagogue in Northeast Philadelphia met in the homes of new transplants to Feltonville in the 1920s. The congregation grew, and in 1929, Brith Israel built its edifice at D Street and Roosevelt Boulevard, with Rabbi Abraham Levy in its pulpit. Jews such as Samuel Heiman and his wife, Belle, a schoolteacher at Olney, moved along with their daughter, Ruth Linda, to the west side of the boulevard to live at 5100 Westford Street. The synagogue closed in 1989, with 1,500 past members in attendance at a closing service. The shul then merged with the Oxford Circle Jewish Community Centre.

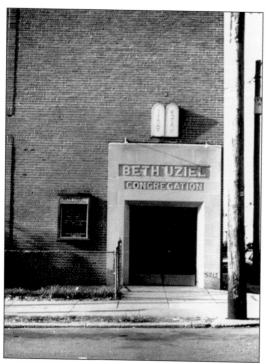

Congregation Beth Uziel of Feltonville, founded in 1938 and chartered in 1943 for the residents in the area near D Street and Wyoming Avenue, engaged Rabbi Ralph Weisburger at its pulpit. Plans to build a synagogue in 1949 ended in disaster with the collapse of the steel framework at Rorer Street and Wyoming Avenue. The new synagogue finally opened in 1954. Rabbis Arthur Weiss, Isidor Barnett, and Oscar Kramer served this congregation until it closed in the early 1990s to merge with Ner Zedek-Ezrath Israel.

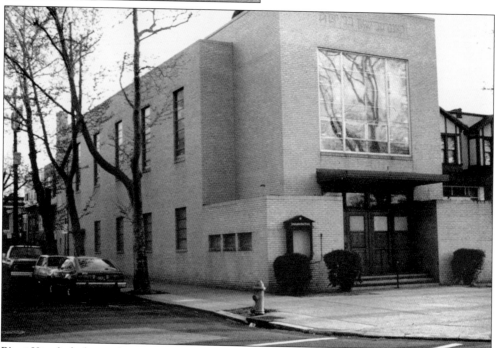

B'nai Yitzchok, better known as the B Street shul, was formed by Austro-Hungarian Jews who broke away from Brith Israel to form their own synagogue in 1924. The double house served the community until 1951, when it built its own edifice. Rabbis Arnold Feldman, Saul Aranov, and Sholem Horowitz served until the 1980s, when the synagogue closed and merged with Beth Emeth.

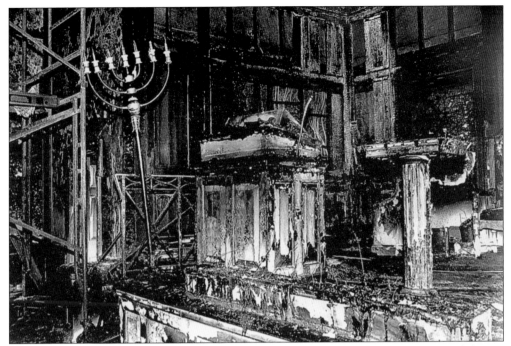

Temple Sholom, the third synagogue to call Roosevelt Boulevard (at Large Street) home, developed in the late 1930s. Rabbi Maurice Kliers, followed by the well-known World War II chaplain, Rabbi Pinchos Chazin, along with lay people from older Jewish neighborhoods, moved this synagogue into prominence. That all came to sudden halt in the early 1990s with a fire.

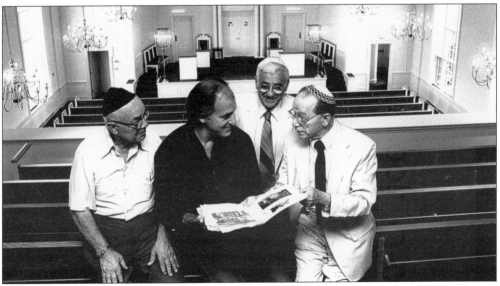

Rabbi Pinchos Chazin, an Oxford Circle institution all by himself, led the Temple Sholom congregation for more than 45 years. After the fire, the opening of the newly renovated sanctuary breathed new life into the rabbi and his congregation. They had relied on a side prayer chapel for daily services while rebuilding took place. (Courtesy of the *Jewish Exponent*.)

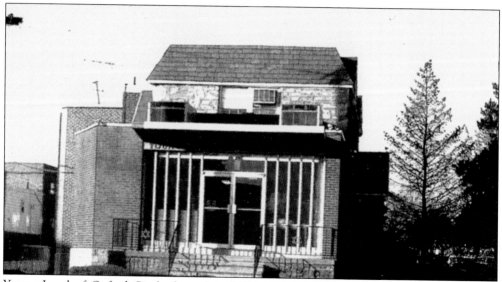

Young Israel of Oxford Circle formed in 1954 at 6427 Large Street as the first Orthodox synagogue in the community. Joe Brown, Sam Sokoloff, and Dr. Weiner gathered in a basement at 1424 McKinnley Street and represented the varied backgrounds of the old Jewish neighborhoods. The national Young Israel movement appealed to the membership, and Rabbi Jules Meles was called on for rabbinical leadership.

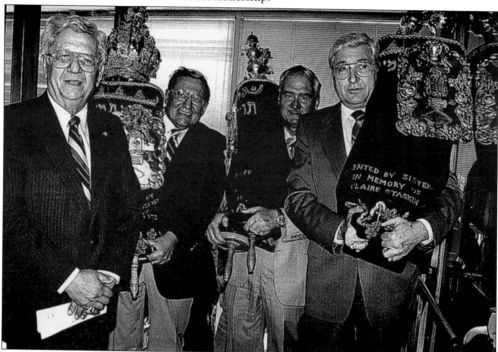

The story of the founding of Congregation Beth Emeth in a farmhouse at Bustleton and Unruh Avenues reads like a story from a movie. The members met, like many, under very large circus tents for High Holiday services in 1952, with carpets donated by individuals to prevent mud during a rainstorm. Irv Cogan, Dr. H. Miller, Alvin Feldman, and Mort Dunoff, all past presidents, triumphed over many obstacles. (Courtesy of the Beth Emeth archives.)

B'nai Jacob-Dirshu Tov, a blended Orthodox synagogue at Gilham and Summerdale Avenues, served scores of former Strawberry Mansion Orthodox Jews who moved into Oxford Circle in the 1950s. Isaac Wachman held services under the Aitz Chaim-Zichron Jacob name at 1327 Elbridge Street before Rabbi Baruch Leizeroski came from 40th Street and Girard Avenue to unite the group in the 1960s.

Congregation Beth Emeth built its synagogue in various stages, as money and needs matched up. The congregation grew to more than 800 families at its peak in 1973. The modern-design building houses a second-floor sanctuary, now reachable by an elevator, a social hall, a kitchen, and a classroom. Many an Israel bond drive dinner took place here, and its active B'nai Brith Youth Organization (BBYO) met for Sunday night dances.

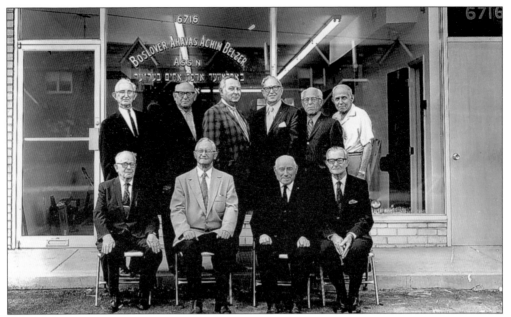

The Boslover Ahavas Achim Association, a beneficial and benevolent society, relocated from South Philadelphia in the early 1960s to 6716 Bustleton Avenue, in order to better serve its members. The Boslover Hall initially held religious services at this location for its members and later rented out the hall to Jewish groups. The familiar storefront became known as a friendly meeting hall over the years. (Courtesy of Sidney Landes.)

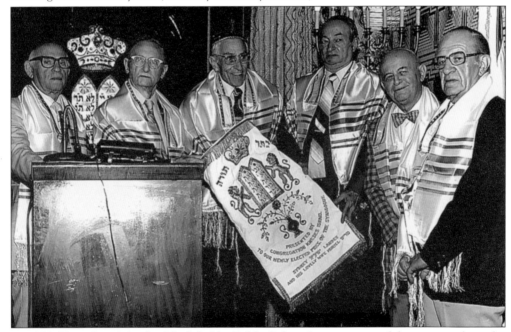

In 1973, Kness Israel Anshe Sfard, led by Rabbi Sidney Lewis, migrated from its perch in the middle of the 900 Marshall Street block to the rabbi's home at 2101 Friendship Street. The Boslover Hall at Bustleton and Unruh Avenues could seat 250 people on the High Holidays for Kness Israel. (Courtesy of Rabbi Sidney Lewis.)

Architecture sometimes gives a hint as to what the owner or, in this case, the community was thinking at the time of construction. The Oxford Circle Jewish Community Centre, with its multiple triangular rooftop, evokes the popular Israeli dance *Hava Nigila*, performed by many people in a semicircle, holding hands. Song and dance played a major role at the Oxford Circle Jewish Community Centre, with its cantor and concerts. The congregation at Algon and Unruh Avenues enjoyed *Jerusalem of Gold*, written by Naomi Shemer in 1966.

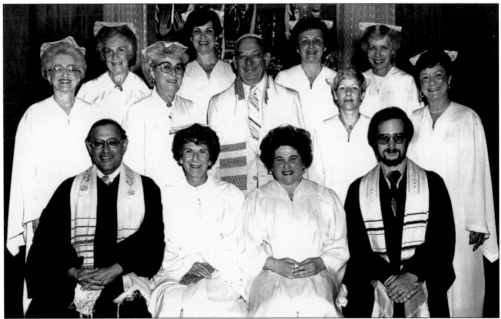

Jewish education, a hallmark of the Oxford Circle Jewish Community Centre, allowed both boys and girls to study the Bible while preparing for a bar or bas mitzvah. The sexual revolution of the 1960s and 1970s in America spilled over into Judaism with the introduction of a b'nai mitzvah program (for adult women to learn how to read directly from the Torah) and paved the way for egalitarian roles for women in the Torah services as approved and amended by the congregation. Here, the ladies pose in 1980 with the rabbi and cantor. (Courtesy of the *Jewish Exponent*.)

Joint programs in the Northeast Council of Synagogues allowed great planning sessions for Rabbis Pinchos Chazin, Hershel Brooks, Harold Romirosky, and David Wachfogel in 1974. (Courtesy of the *Jewish Exponent.*)

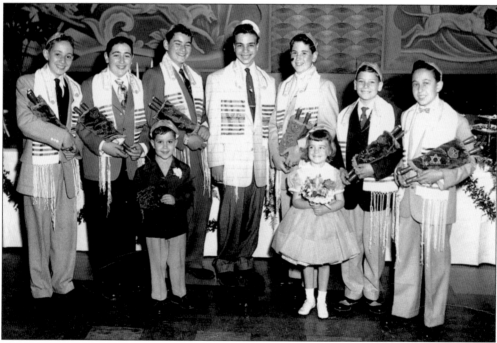

Sharing a bar or bas mitzvah affair meant inviting all your friends and relatives and enjoying each others' company, with one purpose in mind—welcoming the boy or girl into Jewish adulthood at age 13. Here, we see one of those wonderful group photographs with the bar mitzvah candidate—Paul Rosenbaum, in this case. (Courtesy of Len Block.)

Some bar mitzvah boys rebel when they are 13, and future Rabbi Arnold Shuman from South Philadelphia was no different in the 1930s. He later led four Northeast synagogues—Fox Chase Jewish Center, Temple Beth Ami, B'nai Torah, and Adath Zion. (Courtesy of Arnold Shuman.)

B'nai Chaim Social, a benevolent society founded in 1936 by Jacob Tecker, provides its members with social outlets and programs at the Northeast High School auditorium, as well as the opportunity for inclusion in the group's cemetery entitlement at King David Cemetery, located on the west side of Route 1 in Neshaminy. (Courtesy of the *Jewish Exponent*.)

Jewish religious institutions in Philadelphia often follow their members to newer neighborhoods. Congregation Adath Zion of Frankford, founded in 1895, served the business and merchant community there through the first half of the 1900s and then migrated to the 7100 block of Pennway Street in Oxford Circle. A dedication dance at the new shul, which was headed by longtime leaders Albert Lichtenstein, Dr. Maurice Beck, Mrs. Kay Freiberg, and Louis Cobrin, took place in 1956. (Courtesy of the Adath Zion archives.)

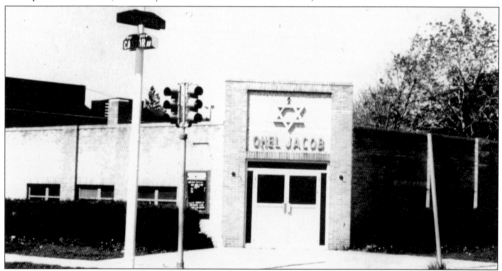

Congregation Ohel Jacob, founded in North Philadelphia in 1910, served as a founding member of the Conservative United Synagogue of America, along with Beth El and Adath Jeshurun. The migration of its members to Logan emptied this community of its members after World War II, and president Samuel Zatuchni, along with Rabbi David Wachtfogel, migrated to Oxford Circle in the early 1950s and built a new synagogue there at 6809 Castor Avenue and Longshore Street in 1957. (Courtesy of Allen Meyers collection.)

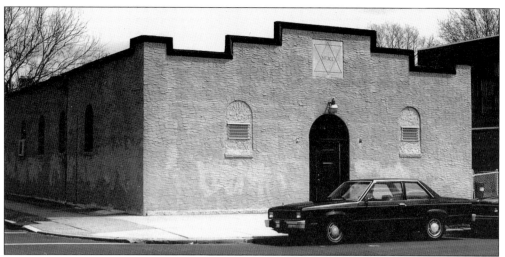

The Tacony Hebrew Club formed in the late 1920s, composed of Jewish merchants from Torresdale Avenue and Longshore Street. The group organized the Northeast Jewish Community Center, built a synagogue in the 1920s-era architectural style on Tyson Avenue off Frankford Avenue, and selected Rabbi Nathan Barnett to lead it.

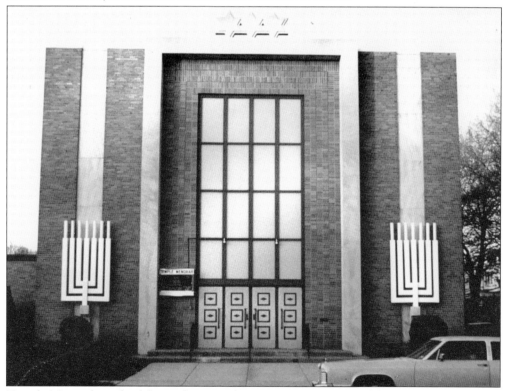

Temple Menorah evolved from a business-district minyan on Torresdale Avenue in the 1920s and became the Northeast Jewish Community Center. After World War II, more Jewish people opened businesses in the Mayfair section of Philadelphia, and Rabbi Abraham Israelitan and his wife, Mollie, led this synagogue from 1947 until the 1990s, building its membership with door-to-door solicitation. The new synagogue opened in the 1950s.

Ner Zedek, a neighborhood synagogue founded in a house near Wilson Junior High School in the early 1960s, emerged as a leading synagogue when it took in Ezrath Israel from West Oak Lane and built its synagogue on Bustleton Avenue and Oakmont Street in 1970. Rabbi David M. Wachtfogel led this wonderful congregation for many years. The synagogue became the first double-hyphenated entity in the 1990s, when Beth Uziel of Feltonville joined them. (Courtesy of the *Jewish Exponent*.)

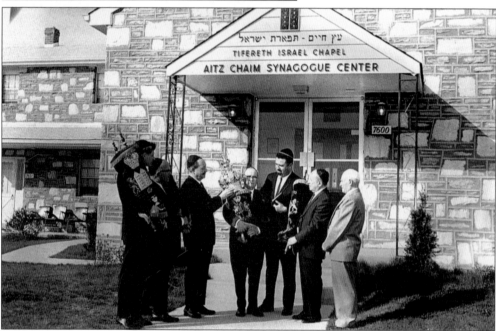

Rabbi Abraham Novitsky, a noted Philadelphia chaplain and counselor to the mentally challenged patients of the Byberry State Hospital, has led the Aitz Chaim Synagogue Center at 7600 Summerdale Avenue since its inception in 1965 as an Orthodox synagogue. Members of closed Jewish synagogues from the old neighborhoods of West Philadelphia and Strawberry Mansion were welcomed here. (Courtesy of the *Jewish Exponent*.)

Allen Rothenberg, a prominent lawyer in Philadelphia and member of Ohev Zedek-B'nai Halberstamm, lends a hand in the groundbreaking for a new synagogue, built around a former farmhouse at Castor and Solly Avenues in the late 1970s. Members came from Seventh and Oxford, and Sixth and Green Streets. This Orthodox congregation accepted members of Logan's B'nai Israel from 10th and Rockland Streets and successfully emerged as a modern Orthodox congregation under Rabbi Felder. (Courtesy of the *Jewish Exponent*.)

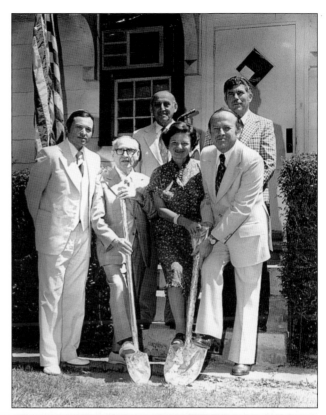

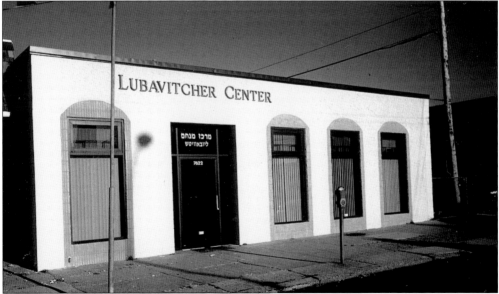

The Lubavitcher Center at 7600 Castor Avenue is home to Rabbi Abraham Shemtov, who came to Philadelphia after World War II and tended to Logan Jews before coming to the Northeast. The center attracts other Orthodox rabbis for prayer and study, and deep discussions of meaning, just as Chief Rabbi Leventhal's congregation Tifereth Israel at 40th and Girard Avenue did a generation ago.

Strict Orthodox congregations filled up in the Rhawnhurst section from the 1960s on, as new housing went up and people migrated to the area in groups. These men, who met in basements of homes, were nicknamed "the underground." The Rhawnhurst Torah Center, chartered in 1975, settled in a home at 7525 Loretta Avenue and formed the Northeast Mikveh Association. They created the ritual bath in the home according to Jewish law. Ahavas Torah became its new name. A new synagogue was built on Rhawn Street past Algon Avenue in the 1990s.

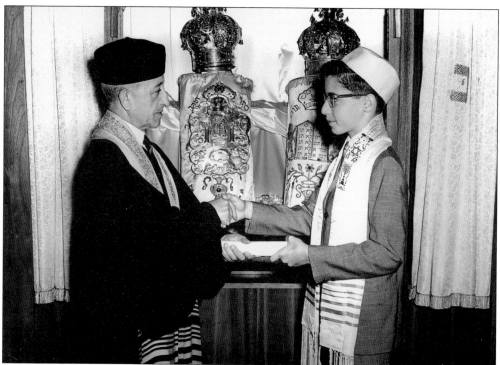

A joyous moment at the Rhawnhurst Jewish Center is shared here between Rabbi Sidney Riback and a young man accepting his bar mitzvah certificate after completing his required readings from the Torah. This rite of passage happens automatically when a boy turns 13 years old. The baton of commitment is the link that connects Judaism from one generation to the next. (Courtesy of Stan Shore.)

Rabbi Goldman of Temple Beth Ami reaches out to a young man to share knowledge and the correct way to "lay tefillin," which include straps with the scripture inscribed in them. The wrapping of the hand and arm with leather, and the placement of the head strap symbolize that a person must think and act with his hands in a righteous manner from the moment he awakens in the morning. (Courtesy of Jack Kapenstein.)

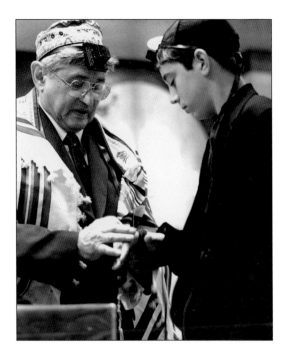

Temple Beth Torah on Welsh Road above Verree Road is the congregation with the most unique history of all the synagogues in the Northeast. The congregation started out as a breakaway of Temple Menorah and looked for land at Tyson and Bustleton Avenues to build on but instead chose to settle on the east side of Roosevelt Boulevard, thus allowing the Solis-Cohen school space to build. After 13 years, its members had migrated to the far Northeast, and in 1963, they decided to rename themselves and open the Welsh Road synagogue.

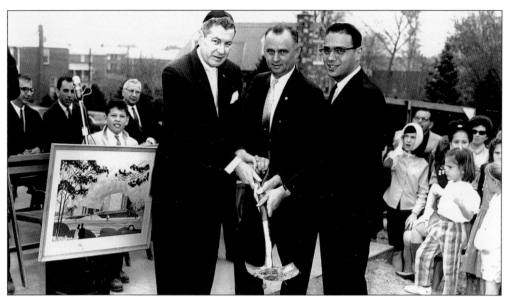

Migration of the Jewish community to the extreme northeast boundaries of the city allowed growth along Verree Road and single-family dwellings in the Golden Gate section. Judge Ed Griffiths, David Silver, and Irv Geboff (not shown) selected the ground for the Greater Northeast Jewish Congregation while riding in a yellow Cadillac convertible up Verree Road in the early 1960s. The synagogue adopted the 23rd and Wharton Streets congregation—Shaare Shamayim—from South Philadelphia and is a leading synagogue today.

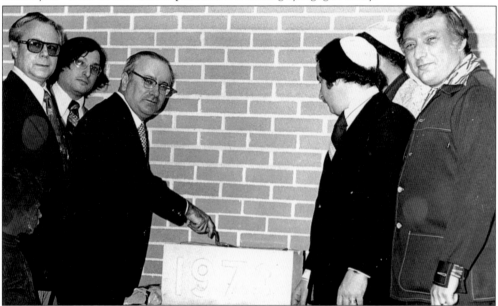

Eastern European Jews settled in the Philmont Heights section of Philadelphia off Bustleton Avenue in the late 1960s, only a mile or two from the Philmont Country Club, a German Jewish institution founded in the early 1900s. The Bustleton-Somerton congregation, led by Ed Goderov, untiring Rabbi Meyer Kramer, Steve Bascove, and Paul Goldenberg, laid the cornerstone to their Tomlison Road synagogue in 1973. The synagogue adopted Beth Judah of Logan in 1980s as they changed the name (Beth Judah, Somerton).

Rabbi Maier Fuchs, a Romanian Holocaust survivor, came under the direction of Rabbi Ephraim Yolles of Strawberry Mansion and took positions in South Philadelphia and Mount Airy before starting his own synagogue in the Welsh Road and Roosevelt Boulevard section of Northeast Philadelphia in 1960, located at 9037 Eastview Street. Two twin homes were converted into one large synagogue by master bricklayer N. Bressi in 1966. Rabbi Fuchs offered unaffiliated families a Jewish education for their children at the synagogue until it closed in 1985.

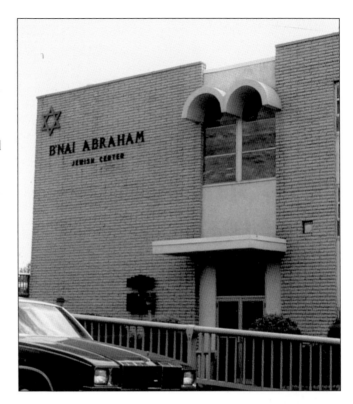

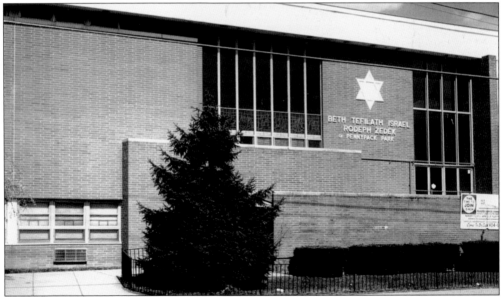

The area east of Roosevelt Boulevard along Welsh Road attracted many new transplanted Jewish residents in the early 1960s, with its large selection of two-story, brick twin homes, with garages in front. A minyan formed in Harry Golluber's home and evolved into the Pennypack Park Jewish Congregation. Cantor Morris Diamond briefly led this congregation until it built its edifice on Welsh Road above Blue Grass Road. The congregation adopted Beth Tefilath from West Philadelphia and Rodeph Zedek of Logan.

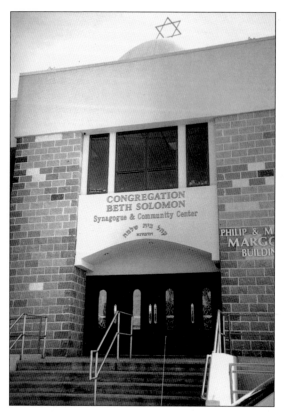

The desire to build a synagogue for the Jewish people of the Philmont Heights section of Northeast Philadelphia has come true for Rabbi Solomon Isaacson, who came with his father to Philadelphia in the late 1940s. They settled in South Philadelphia and Mount Airy, and when his father migrated to Staten Island, Rabbi Solomon moved to the Northeast and made a shul in his home. Rabbi Solomon retrains Russian émigrés back into Judaism, and he erected the first new synagogue of the 21st century in Philadelphia.

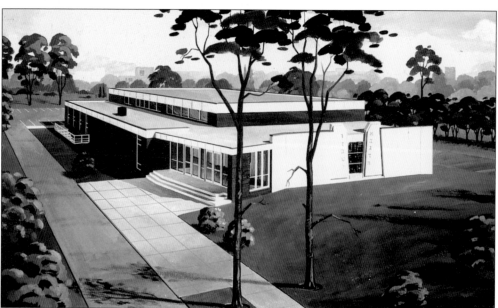

In the early 1960s, new housing attracted young Jewish families to the area along Academy Road known as Morrell Park. The Jews in this area united under the leadership of Norman Domash, who secured Rabbis Gerard Lerer, Sheldon Freedman, and Arnold Shuman to lead this group of residents. They built their edifice at 11082 Knights Road in the 1960s.

Ten

COMMUNITY AFFAIRS

Northeast Philadelphia has encompassed the greatest diversity of Jewish residents, with many denominations of Judaism living side by side. Community service, provided by individuals, groups, or the Jewish Federation, was unmatched anywhere in America. The dynamics of the community revolved around the relocation and migration of thousands of Jews from around the city to the Northeast as old traditional neighborhoods declined, from the 1950s though the 1980s. Others from outside of Philadelphia came, too, including Holocaust survivors, Russian émigrés, and Israeli citizens. B'nai Brith, a national benevolent society founded by German Jews in the mid-19th century, joined the modern-day rally in Philadelphia for the release of Soviet Jewry. In this photograph, Kathryn Beonarz signs a huge billboard at Penn's Landing in the 1980s. (Courtesy of the *Jewish Exponent*.)

Young supporters of freedom for Soviet Jewry gathered in the synagogues of Northeast Philadelphia, with confirmation classes devoted to understanding the plight of the Russian Jews. This activity developed into an organization to assist individuals from Russia in settling in the Northeast. Synagogues adopted whole families and sent money to Jewish organizations to assist in the migration to America. The class at Shaare Shamayim took an active role in this community forum. (Courtesy of the *Jewish Exponent*.)

Jacob Riz of 1453 Levick Street dedicated a portion of the basement of his home to showing the community the atrocities that Hitler perpetrated on the Jews of Europe. The former Auschwitz and Siberian labor camp prisoner created this museum so that no one would forget what happened during the 1930s and 1940s. Jacob went to public and parochial schools to teach how hatred could lead to genocide. His collection of artifacts predated the Holocaust-awareness movement in America. (Courtesy of the *Jewish Exponent*.)

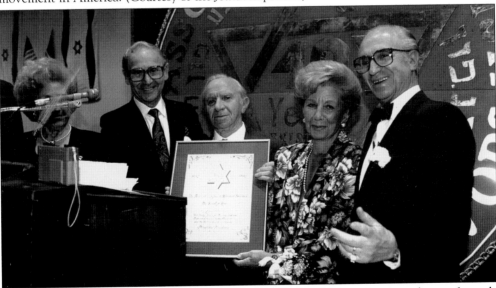

The Association of Holocaust Survivors formed in Philadelphia and was made up of people from the displaced persons camps who arrived here in the late 1940s. This support group joined resources to sponsor individuals in need of housing, jobs, and fellowship. The New Americans president Abe Shnaper received an award for his work from Sam Petta, Luba Shnaper, and Menachem Kozuch, which met at the Oxford Circle Community Centre. (Courtesy of the *Jewish Exponent*.)

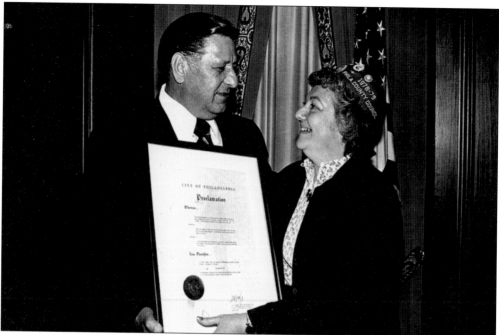

Politics entered into Jewish life, especially during the 1970s. Mayor and former police commissioner Frank Rizzo received an award from the Driesen-Weiss Jewish War Veterans post on Tyson Avenue for his program to clean the streets of Northeast Philadelphia every Wednesday during the spring of 1976. (Courtesy of the *Jewish Exponent*.)

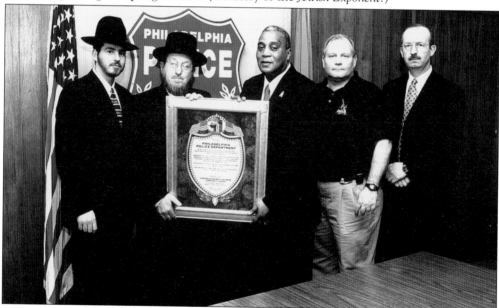

An award of appreciation is presented by Rabbi Shloime Isaccson; his father, Rabbi Solomon; police commissioner Sylvester Johnson; captain Mark Fisher; and deputy commissioner Charles Brenner to the Philadelphia police for their rapid response to the attack on America on September 11, 2001, in New York City. The award is in the shape of a police badge. (Courtesy of the *Jewish Exponent*.)

Sponsored by the Jewish Federation, Prime Minister Golda Meir of Israel came to Philadelphia in 1969 to call attention to the economic needs of her country. The event at Shaare Shamayim synagogue on Verree Road drew a large attendance and a generous donation to the Israel bond drive after the massacre of Israeli athletes in Berlin during the 1972 Olympic games. Northeast Jews bought the popular $100 bonds in record numbers to show their support. (Courtesy of the *Jewish Exponent*.)

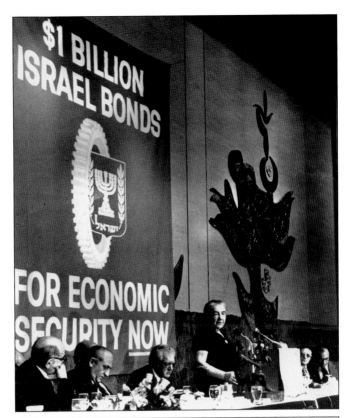

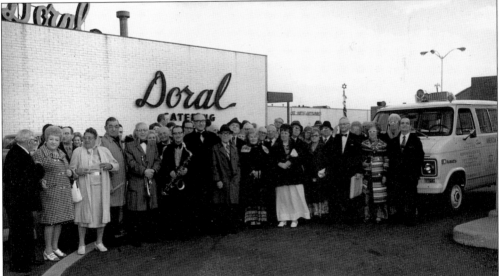

The proud state of Israel was founded in 1948 as a homeland for Jews around the world who had nowhere to go after World War II. The continuous support for Israel by Philadelphia Jews is a five-decade-old tradition, which has taken many forms. The Ahavas Achim Belzer Association, represented by Len Gold, David Landes, Joseph Goldstein, William Sherman, Maurice Weiss, Abe Stern, and Harry Beitchman, here presents the state of Israel with an ambulance at Doral catering hall on April 29, 1973. (Courtesy of David Landes.)

The very first Federation service for older adults took place in the early 1970s on Castor Avenue in the former Linton's restaurant. The comfort station offered elderly Jewish people an outreach program by just walking and talking to Jewish family service for medical, housing, and social needs. (Courtesy of the *Jewish Exponent*.)

Apartment living is a tradition in the Northeast that dates back to the late 1940s. Newly married couples rented space in the areas in which they later expected to purchase a home, such as Algon and Summerdale Avenues, Roosevelt Boulevard, and Blue Grass, Welsh, and Red Lion Roads. These refurbished apartments are serving the same generation again, years later in the 1990s, as empty-nest parents sell their homes and return to apartment living.

A century of life is celebrated by William Weisman, a longtime Philadelphia resident, and Rabbi Nason Goldstein at the Uptown Home for the Aged at 7700 Bustleton Avenue, originally located at 957 North Franklin Street. William celebrated his 100th birthday in May 1990 with a special bar mitzvah. A tradition has emerged that, since the Bible speaks of a man's life as three score and ten, when a man lives 13 years beyond that date and reaches age 83 or above, he should reaffirm himself. (Courtesy of the *Jewish Exponent*.)

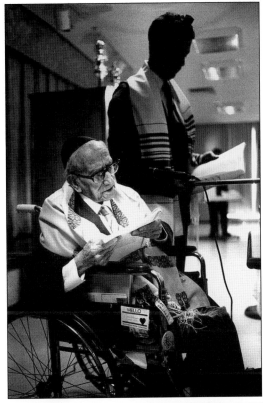

Jewish Federation housing started in the 1960s, when "shut-ins" living at the Park Manor apartments on North 33rd Street in Strawberry Mansion refused to leave the area after it declined and then became a non-Jewish neighborhood. Ephraim Goldstein and state representative Joshua Eilberg spearheaded the program to build apartment buildings that would allow elderly Jewish people a sense of dignity and the ability to live independently in a community environment. The Tabas House at 2100 Strahle Street opened in the early 1970s.

The presentation of funds to various community institutions is an age-old Jewish tradition. This sense of duty and responsibility goes beyond just dispensing money to community projects; it underpins the deep-rooted value of communal pride for Jews. Max Riser, a well-known Philadelphian and wine dealer on North Broad Street in Logan, is presented an award of appreciation here from the Philadelphia Talmudical Yeshiva.

A mitzvah is a tremendous concept in Judaism. Rabbi Oscar Kramer, originally from South Philadelphia, led congregation Beth Uziel on Wyoming Avenue and founded the Judaic Institute for Jewish children with learning disabilities. The program addressed the needs of handicapped children who aspired to celebrate their bar or bas mitzvah. Here, Rabbi Kramer is presented with an award for his work by Sylvia Zipkin and her son, Marty, in October 1983. (Courtesy of the *Jewish Exponent*.)

Religious court in Judaism is separate from civil court and requires a board of three or more elders who can rule on community affairs or individuals. The Philadelphia Beth Din, under the auspices of the Rabbinical Council of America, was set up in 1968. The Northeast Rabbis included Joseph Rothstein, Dov Schwartz, Ephraim Yolles, and Saul Aranov. The most pressing issue of the day became divorce, as civil law did not address the requirements of full separation in order for a Jew to marry another Jew. (Courtesy of the *Jewish Exponent*.)

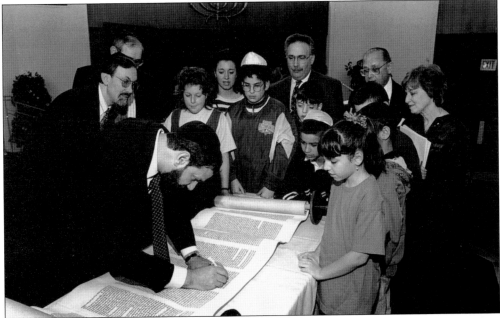

What an honor to repair the holy scriptures of the community! The Torah scroll is more than just a document, and repairing it requires the skill of Hebrew calligraphy, according to ancient rites and rules. Rabbi Isaac Leizerowsky, the son of Rabbi Baruch, is a trained scribe and works very diligently here to repair a Torah scroll. This community event took place at the Oxford Jewish Community Centre, with Rabbi Harold Romirowsky and Hebrew school students as witnesses. (Courtesy of the *Jewish Exponent*.)

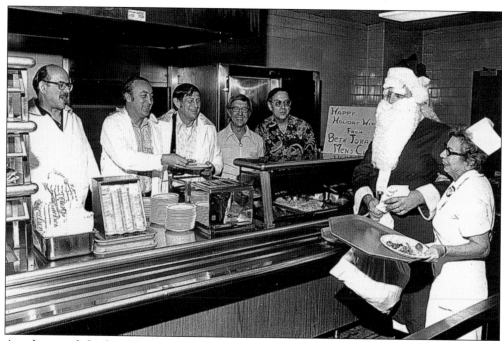

Another good deed in Northeast Philadelphia is performed annually at the Holy Redeemer Hospital on Huntingdon Valley Pike. The nearby Temple Beth Torah men's club volunteers time as cafeteria workers to allow non-Jewish workers time to spend with their families on Christmas Day. Even Santa Claus stops by to get some good hospital food. (Courtesy of the *Jewish Exponent*.)

In the late 1990s, a fire caused extensive damage to the Beit Harambam synagogue (on the 9900 block of Verree Road), founded by Rabbi Amiram Gabay, who is also the owner of the Israeli-Jerusalem gift shop on the 7800 block of Castor Avenue. The community responded immediately and Kal Rudman, a local philanthropist, along with police captain John Appledorn, presents a check here for the rebuilding of this Jewish house of worship. (Courtesy of the *Jewish Exponent*.)

At the Moses Montiefore Cemetery on Church Road in Rockledge, Russian Jews marked the 47th anniversary of the Babi Yar massacre, which took place in 1942 on the outskirts of Kiev. This Nazi-perpetrated atrocity piled 33,000 Jewish people, all shot by rapid machine gun fire, into a common mass grave. Shimon Kipnis, a recent Russian émigré, takes part in saying the Kaddish—the prayer for dead—at the community service in October 1989. (Courtesy of the *Jewish Exponent*.)

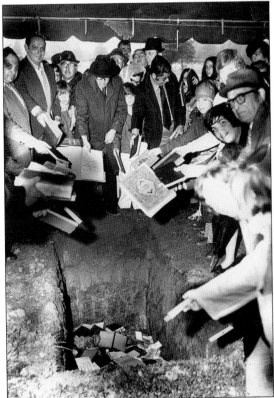

The ancient Jewish custom of burying unusable (nonkosher) articles of everyday Jewish life is carried out in the modern 20th century with a community service and dedication. Hebrew books with tattered pages; worn out tefillin sets; and old, frayed *talis*, or prayer shawls, are given a dignified resting place in the *genizah*. This ceremony took place in 1976 at the Mount Carmel Cemetery on Frankford Avenue and involved several Northeast synagogues and their members. (Courtesy of the *Jewish Exponent*.)

A community monument marks the entrance to a South Philadelphia *Landsmanschaften* organization, known as the Philadelphia Banner Lodge, inside the Har Nebo cemetery on Oxford Avenue at Summerdale Avenue.

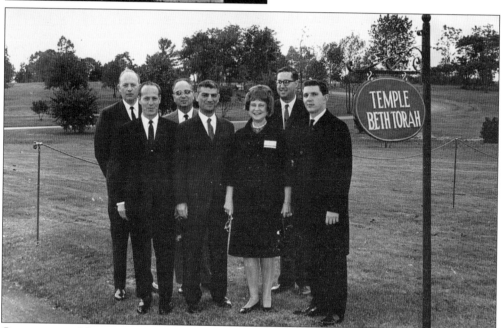

Congregational lots are still in vogue at area Jewish cemeteries, as we see in this photograph of Temple Beth Torah of Welsh Road meeting to dedicate its communal burial ground at Shalom Memorial on Pine and Byberry Roads. Seen here in 1965 placing a post to mark this consecrated ground are, from left to right, Stanley Zelrich, Norman Grossman, Mort Cohen, Berta Shay, Robert Shay, and Rabbi Frederic Dworkin. (Courtesy of the *Jewish Exponent*.)

Eleven

THE END OF AN ERA

The Jewish generation that settled in Northeast Philadelphia is coming to an end. The parents of the baby boomers of the late 1940s and 1950s have led fabulous lives, raised families, built synagogues and community institutions, and provided a Jewish education for their children. Northeast Philadelphia is graying as this group moves into its natural final stages of life. During the writing of this book, in the spring of 2004 alone, the author, a longtime resident of Northeast Philadelphia, witnessed the closing of many landmarks and community institutions that have been a major part of the Northeast Jewish community's life. This private house on Castor Avenue displays the flags of many veterans who served in the military and is a tribute to the residents themselves.

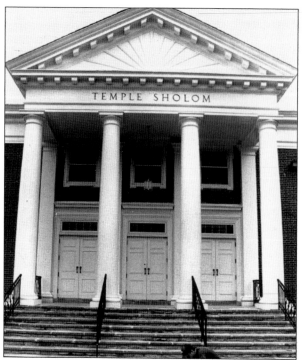

Temple Sholom, founded by a group of Jewish pioneers who settled in Northeast Philadelphia during the early 1940s, is a testimony to the treasured religious freedom Jews have here in America. Abraham Albert, joined by Rabbi Maurice Kliers, Saul and Sam Zukerman, Max Korman, Cantor David Blumberg, and Rabbi Pinchos Chazin, created this great institution, which, sadly, closed its doors in 2004, 65 years after its founding, and merged with Beth Sholom on Old York Road. (Courtesy of Jack Kapenstein.)

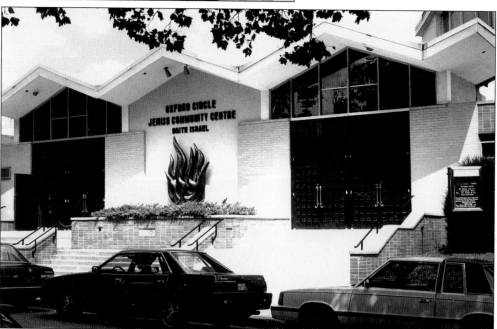

The rabbis of Northeast Philadelphia are a very special, hand-picked group of individuals who lived in the same community as their congregants. Rabbi Harold Romirowsky came to the Oxford Circle Jewish Community Centre in 1954. He led his congregation for the next 45 years, promoting the synagogue that was founded in Joseph Konefsky's and Jack Polsky's basements to provide Hebrew classes for their children. This congregation, which once boasted 1,000 families, closed in 2004 and merged with Adath Jeshrun in Elkins Park.

If you traveled up Bustleton Avenue past Roosevelt Boulevard and along the Route No. 59b bus in the 1950s, you would have come to the third most important community institution after the I. Peretz Workman's Circle School and the Max Myers Playground at Magee Avenue—the Neighborhood Centre. The turn over to the Newman Center Senior Center closed in the spring of 2004, and services shifted north to the Klein branch of the Jewish Community Center on Red Lion Road.

History does repeat itself, at least for some in the Jewish community. The old Talmud Torah opened in 1929 at Marshall and Porter Streets in South Philadelphia to serve the area's children. Those same children later used the facility as senior adults. The author's own late mother-in-law, Gloria Gendelman Manusov, had that experience. The author, Allen Meyers, played at the Bustleton Avenue Neighborhood Centre and, 40 years later, gave lectures on old Jewish neighborhoods at the same location, and at the same auditorium in which he once played basketball.

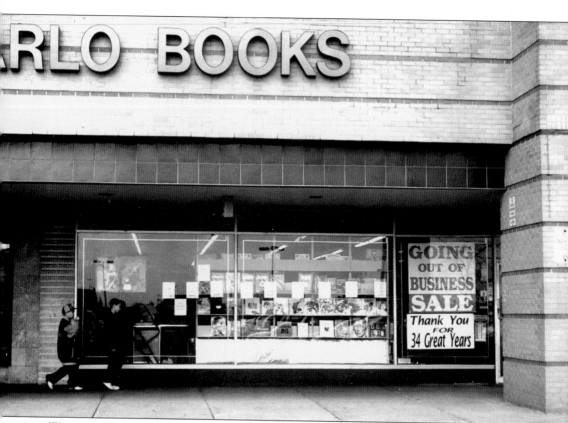

We miss Curt and Rita Broad, who managed Marlo Books, located in the Roosevelt Mall, a place people went every week to stroll its long promenade of stores, from one end to the other, as they shopped for books, records, new fashions, and shoes. Marlo Books, a place to stop for summer reads and the popular new bestsellers, became a memory as of May 2004.

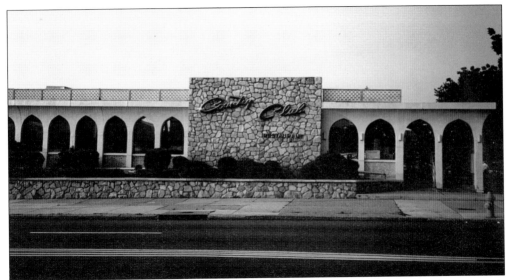

Noel Perloff and his family opened the Country Club Diner in 1956 on Cottman Avenue, with nothing but open farmland around. Many changes have occurred over the years, with the opening of Northeast High School and the shopping centers from Castor Avenue to Roosevelt Boulevard. The family sold their business in May 2004. It remains open, though under different ownership, and though the author and others still go there, they will miss Noel coming by their table, asking whether the matzo ball soup is hot enough, and then engaging in neighborhood conversation.

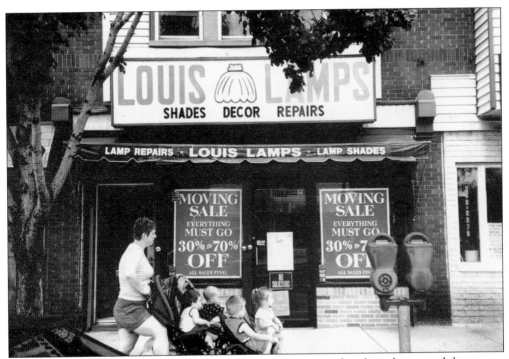

Louis Lamps on Frankford Avenue above Cottman Avenue closed its doors, as did so many others, in May 2004. Louis, a member of Temple Menorah, had passed the business to his son before his passing. The call for pole and table lamps is now a memory.

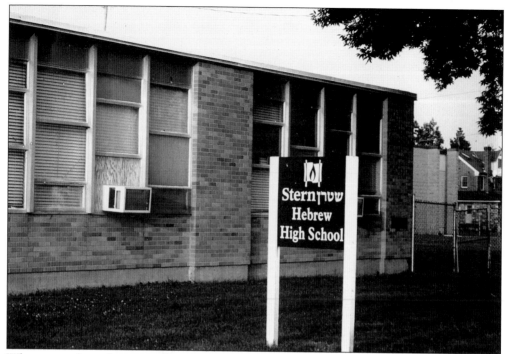

Where one door closes, another door opens. Adath Tikvah on Summerdale Avenue and Hoffnagle Street merged with Ohev Sholom in Richboro in 2003. One year later, in the spring of 2004, the fully accredited Hebrew high school graduated its first class.

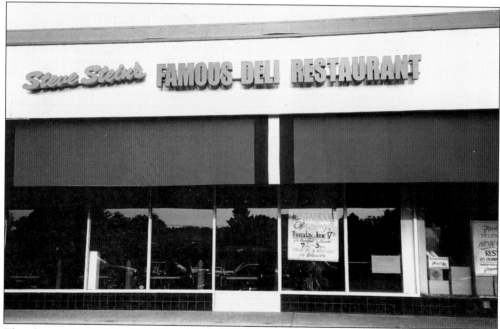

The changes in the Northeast Jewish community do not mean that it is going away completely. The community lives on, as we see in Steve Stein's fully renovated delicatessen and new restaurant, which opened on Krewstown Road in the K-Center in the spring of 2004.